# Bruegel

Keith Roberts

with notes by Christopher Brown

Phaidon · Oxford

Phaidon Press Limited, Littlegate House, St Ebbe's Street, Oxford OX1 1SQ

First published 1971
This edition, revised and enlarged, first published 1982
© Phaidon Press 1981
Introductory essay © Keith Roberts 1971, the estate of Keith Roberts 1979

British Library Cataloguing in Publication Data

Roberts, Keith
    Bruegel. - 3rd ed.
    1. Bruegel, Pieter
    I. Title      II. Brown, Christopher
    III. Bruegel, Pieter
    759-9493      ND673.B73

    ISBN 0-7148-2225-6
    ISBN 0-7148-2239-6 pbk

Typeset, printed and bound in Singapore under coordination by Graphic Consultants International Private Limited

The publishers wish to thank all private owners, museums, galleries and other institutions for permission to reproduce works in their collections. Particular acknowledgement is made for Figures 2, 3, 4, 5, 13 and 36, which are reproduced by Courtesy of the Trustees of the British Museum and for Plate 21, which is reproduced by courtesy of the Trustees, The National Gallery, London. Figure 6 is reproduced by courtesy of the Oskar Reinhart Collection, 'Am Römerholz', Winterthur, and Figure 37 is a City of Detroit Appropriation, reproduced by courtesy of the Detroit Institute of Arts.

# Bruegel

# Bruegel

A hundred years ago it would not have been possible to buy a book on Pieter Bruegel; none existed. And even had there been one available, few purchasers would have been found. Although the French critic Thoré-Bürger — the rediscoverer of Vermeer — could write in 1862 that Bruegel was 'a true master whose importance is under-estimated', most people of taste would have echoed the hostile tones of the contemporary German art historian, G. F. Waagen, who wrote: 'His mode of viewing these scenes [of peasant life] is always clever but coarse; and even sometimes vulgar.' That the climate of critical opinion has changed drastically is demonstrated, in a modest fashion, by the existence of the book that you are now reading, one of a low-priced series in which only the most celebrated popular artists can be included.

There are two main reasons for this shift in Bruegel's critical fortunes. The first is linked to the greater degree of tolerance that has characterized our aesthetic responses since the middle of the nineteenth century. We are prepared to look at the arts of different periods and cultures with a lack of prejudice that would have astonished (and slightly appalled) a connoisseur of the mid-Victorian age. Waagen himself was a man of traditional, somewhat exclusive taste who worshipped the pictures of that master of idealized images, Raphael. We are also less prudish, and the frankness of much of Bruegel's imagery, a source of embarrassment to the Victorians, presents few problems to a generation that is not over-anxious about decorum. This loosening of critical bonds has in turn encouraged scholars to work on Bruegel and fill in, and in many places correct, the shadowy outlines of life and reputation that were all that were generally known. We can now be sure, for instance, that Bruegel was not himself a simple peasant, as nineteenth-century critics still believed, but a cultured man in contact with some of the best minds of the day. But although we know more about him than ever before, Bruegel remains, by twentieth-century standards of veracity, as dim and shadowy — and in many ways as ambiguous — a figure as Shakespeare.

The second reason for Bruegel's great modern reputation is connected with the development of photographic reproduction. Lest this sound ungallant, it should be recalled that he is not an artist with a central towering masterpiece that has become of focus of cultural pilgrimage, like Michelangelo's *Sistine Ceiling,* nor is he a painter, like Rembrandt, Cézanne or Renoir, with a large output generously scattered through the galleries of Europe and America.

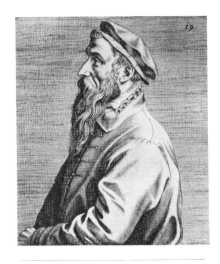

Fig. 1
Portrait of Bruegel

ENGRAVING FROM DOMINICUS
LAMPSONIUS, 'PICTORUM ALIQUOT
CELEBRIUM GERMANIAE INFERIORIS
EFFIGIES', ANTWERP, 1572

His surviving pictures are few in number — under fifty — and not always conveniently located. Of the five in Great Britain, the most easily accessible, the National Gallery's *Adoration of the Magi* (Plate 21), is not representative of his finest manner, while the Hampton Court version of *The Massacre of the Innocents* (for the Vienna version, see Plate 38) is damaged and distorted by over-paint to an apparently irrevocable degree. Two are in the Courtauld Institute Galleries and the fifth, the magnificent *Death of the Virgin* (Plate 22), which once belonged to Rubens, is in a National Trust house near Banbury. Germany can claim five publicly exhibited works, the United States three. Only in Vienna, which has fourteen paintings, can Bruegel be fully appreciated.

But it is unlikely that everyone who cares for his work has been there. What they have been brought up on are reproductions, which are often very good precisely because Bruegel's paintings, with their sharp outlines and clear, simple colours, reproduce well. With the work of many great artists, photography, as a passport to mass popularity, has been a tragically mixed blessing. The average colour reproduction of an El Greco bears as much relation to what the artist intended, and painted, as the first rehearsal of the *Jupiter Symphony* by an amateur orchestra represents what Mozart wanted the world to hear. With Bruegel, however, the loss is not quite as great. He does not depend, to such an extent, on subtleties of colour, and he filled his pictures with tiny figures and incidents that lend themselves to exclusive inspection in isolated details. As early as 1604, the painter-historian, Carel van Mander, touched on this aspect of Bruegel's art when he described 'a *Massacre of the Innocents* [probably the Hampton Court version], in which we find much to look at that is true to life …: a whole family is begging for the life of a peasant child which one of the murderous soldiers has seized in order to kill, the mothers are fainting in their grief, and there are other scenes all rendered convincingly.'

The fact that an artist's work reproduces well need only have a bearing on its character, not its quality. Equally, the capacity to appreciate what was despised in an earlier age may indicate no more than an indiscriminate hungering after mere novelty and sensation. But Bruegel's reputation is not founded on shifting sand: he is a great artist whichever way you look at him, in his own milieu, where he can confidently be claimed as the most profound painter to emerge in Flanders in the century and a half that divides the age of Jan van Eyck from that of Rubens, and in absolute terms as well.

The quality of Bruegel's work puts him on a level with Van Eyck and Rubens; but its character and the orientation of his career serve rather to separate him from them. Unlike his great com-

patriots, Bruegel held no positions at court, he did not produce altarpieces for churches and he did not paint portraits — which is hardly surprising in view of his unflattering style. Van Eyck, master of a style hitherto unparalleled in the range of its naturalistic effects, and Rubens, the leading pioneer and greatest exponent of the Baroque idiom in Northern Europe, were both in their different ways revolutionary artists. Though influential, Bruegel was not. If *The Procession to Calvary* (Plate 17), *The Peasant Dance* (Plate 45) or *The Gloomy Day* (Plate 26) seem highly original, this is essentially a tribute to their quality rather than their character. A strong archaic element runs through Bruegel's paintings, drawings and prints, and it is not only expressed in design — *The Procession to Calvary*, for example, goes back to an Eyckian pattern — but also revealed, more significantly, in the fundamental approach to art itself. Bruegel's vision — the suggestion of a world in miniature; the passion for endless detail; the abrupt contrasts between the literal and the fantastic; the mixture of brutality, licentiousness and guilt — his whole way of seeing things belongs to the dying Middle Ages. Even the seemingly straightforward seasonal landscapes (Plates 26, 34, 30) belong to a systematized, descriptive tradition that had its direct roots in medieval illuminated manuscripts. From one point of view, Pieter Bruegel can be regarded as the last great medieval painter.

Bruegel was not concerned with achieving an illusionistic degree of finish, an attitude which set him apart from most of his contemporaries; and he did not share that interest in idealized figures that was becoming increasingly fashionable in sixteenth-century Flanders and which Rubens was to make one of the cornerstones of his art. Bruegel was indifferent to the concept of ideal beauty, and was incapable of realizing it in an acceptable manner when its presence was obviously indicated. Who would imagine, on being confronted by the sly, hooded mother and her elderly child receiving homage from the enfeebled fanatic who kneels before her, that this was meant to represent the *Adoration of the Magi* (Plate 21), a crucial moment in the history of the Christian faith? The painting is grotesque to the point of parody — which was certainly not the intention: there is no evidence to suggest that Bruegel was anything but an orthodox Roman Catholic who worked for likeminded patrons. The point is even more clearly made in *The Procession to Calvary* (Plate 17). It is impossible to look at this picture for long without being struck by the great difference in style between the main part of the scene and the holy figures at the bottom. They are of a type common in Flemish painting a hundred years earlier. The implication is clear. Incapable of creating for himself suitably idealized sacred images, Bruegel was reduced to

aping the style of a previous age, which gave his holy figures (the three Maries and St John the Evangelist) a remote and, by extension, pious air.

Although Bruegel was famous in his own lifetime, the archaic tone of much of his imagery and his refusal to adopt the idealized figure style evolved by Italian Renaissance artists had, in sophisticated circles, an adverse effect on his reputation both during his life and after his death. His works did not conform to current aesthetic theories, with the result that the still primitive historical sense of early writers on art was not stimulated to any illuminating degree by his career. There was no one to interview him, and to record his thoughts on art — as happened in the case of Michelangelo — and if he wrote any letters, none survive.

Even the date and place of Bruegel's birth are uncertain, although the general consensus of opinion is that he was born near Breda about 1525. According to Carel van Mander, the painter-historian who included a life of Bruegel in his *Schilderboek* published in 1604, the young Bruegel was apprenticed to Pieter Coeck van Aelst, a successful Italianizing artist who maintained studios in Antwerp and in Brussels, where he died in December 1550. To modern eyes Coeck's work is not particularly sympathetic, but that does not mean that it could not have influenced the greater artist at a time when he was a young and impressionable studio apprentice. Bruegel certainly knew Coeck's series of woodcuts illustrating Turkish life and manners, which were based on drawings made in 1533 (posthumously published in 1553). They look slightly absurd now, but with their rich store of exotic facts they may well have created in Bruegel's mind the same impression, of the strange made familiar by virtue of circumstantial detail, that we receive from his own later *Tower of Babel* (Plate 15). In both cases it is as well to remember that the sense of evidence in the sixteenth century was more naive and irrational than our own. In a period when scientific investigation was in its infancy (when it was not being banned altogether by the religious authorities) and when faith itself was often counted a part of knowledge, witches were a definite possibility, even a fact. Shakespeare's assumptions as to what his audience would accept as credible are in this respect extremely revealing. It is this sense of fact, permeated by religious faith, which gives even to Bruegel's most bizarre creations — *The 'Dulle Griet'* (Plate 8), for example, or *The Triumph of Death* (Plate 10) — their curiously objective character. This, Bruegel seems to be showing us, is how it is — in the light of day.

In 1551 Bruegel became a Master of the Antwerp Guild, an indication that he had finished his training satisfactorily and was fit to set up a studio on his own. In 1552, 1553 and possibly for part of

1554 he travelled abroad. In 1552 he was in the south of Italy, visiting Reggio Calabria, Messina, Palermo and Naples, and in the following year he was in Rome, where he came into contact with a well-known painter and miniaturist of the day, Giulio Clovio (later a friend of El Greco), who acquired a number of his works (now lost) done at this time. These included a *View of Lyons* painted in watercolours — a technique Bruegel may have learned from Pieter Coeck van Aelst's wife, Mayken Verhulst Bessemers, who was a specialist in the medium. That he was familiar with the watercolour technique is evident from his paintings, where the oil medium is used with the same degree of delicacy and transparency. The late pictures on canvas, *The Parable of the Blind* (Plate 48) and *The Misanthrope* (Plate 50), show this particularly well. The *View of Lyons* and a miniature of *The Tower of Babel* that Clovio also owned imply that Bruegel was already concentrating on landscape, a deduction corroborated by an extensive series of drawings of the Alps that he made on this journey (Fig. 2). On his return to Flanders, Bruegel began to work for the Antwerp engraver and

Fig. 2
Solicitudo Rustica (Country Concerns)

PREPARATORY DRAWING FOR AN ENGRAVING IN THE 'LARGE LANDSCAPE' SERIES. PEN AND BROWN INK OVER BLACK CHALK, 24.4 × 35.2 CM (9⅝ × 13⅞ INS). LONDON, BRITISH MUSEUM

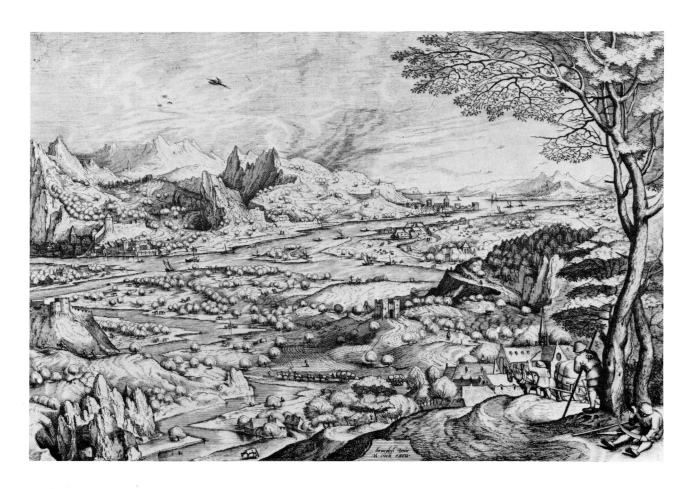

Fig. 3
Solicitudo Rustica (Country
Concerns)

ENGRAVING BY HIERONYMOUS COCK
AFTER BRUEGEL'S DRAWING. 32.4 × 42.5 CM
(12¾ × 16¾ INS). LONDON, BRITISH MUSEUM

print-seller, Hieronymus Cock. The Alpine sketches that he had made formed the basis of a number of elaborate landscape designs (dated from 1555 onwards) which were actually engraved by other artists (Fig. 3). Cock was presumably pleased with Bruegel's work for he was soon employing him on figure compositions as well. Of these, the series of *The Seven Deadly Sins* (1556–7) and the famous *Big Fish Eat Little Fish* are typical early examples (Figs. 4 and 13). Like most of Bruegel's work, they deftly combine entertainment with serious moral instruction. The style is — and was intended to be — consciously reminiscent of the art of Hieronymus Bosch (active 1480/1 — died 1516) (Fig. 8). Cock had already been very successful with prints of Bosch's designs, and it is interesting to note that while the composition of *Big Fish Eat Little Fish* is definitely by Bruegel (there is an authentic preparatory drawing, now in Rotterdam, signed by him and dated 1556), the engraving was first issued under Bosch's name. The connection between the two artists was recognized by contemporaries: a Latin epigram of

1572 refers to Bruegel as 'this new Hieronymus Bosch'.

For the rest of his life Bruegel was active both as a painter and designer of prints, and the two activities were closely linked. The same theme sufficed for both media. The engraved Alpine landscapes of the later 1550s can be compared with paintings like the *Parable of the Sower* (Fig. 5), and prints such as the *Seven Deadly Sins* series with the '*Dulle Griet*' (Plate 8).

In 1563 Bruegel married Mayken, the daughter of his old teacher, Pieter Coeck van Aelst. The couple went to live in Brussels, where the painter died in 1569, probably still only in his midforties. During the last six years of his life Bruegel was much influenced by Italian Renaissance art, whose monumentality of form he found increasingly sympathetic. This influence is evident in *The Peasant Wedding* (Plate 42), *The Peasant Dance* (Plate 45) and *The Peasant and the Birdnester* (Plate 47), especially when they are compared with earlier pictures like *The Triumph of Death* (Plate 10): the figures are now larger in scale and closer to the

Fig. 4
Superbia (Pride)

ENGRAVING IN THE 'SEVEN DEADLY SINS'
SERIES, 22.5 × 29.5 CM (8⅞ × 11⅝ INS).
LONDON, BRITISH MUSEUM

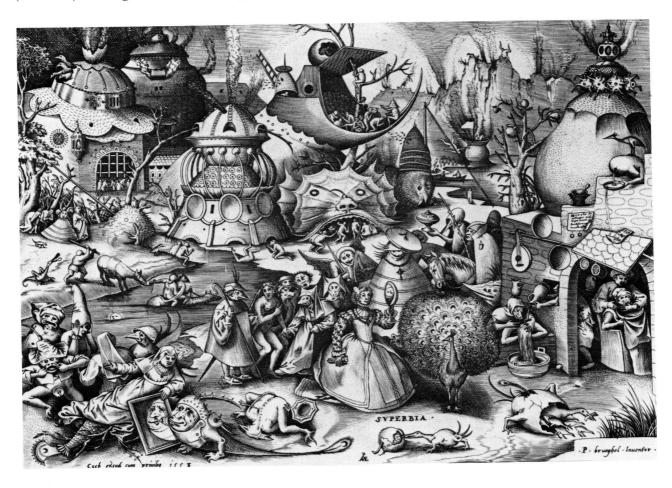

spectator, the viewpoint is lower and there is less concern with the setting.

In spite of these radical developments, however, Bruegel continued to produce paintings in his old style, with tiny figures in a panoramic space. The New Testament subjects set in contemporary Flanders are particularly important: *The Massacre of the Innocents* (Plate 38), *The Numbering at Bethlehem* (Plate 37) and *The Adoration of the Kings in the Snow* (Fig. 6).

Bruegel's contemporary reputation and presumably much of his income depended on the designs that he made for professionally engraved and widely circulated prints of landscapes and various themes of a religious or allegorical nature. His paintings cover the same range of subjects and are conceived according to the same principles of design; in both media, the wide panoramic composition and high viewpoint are adopted. Bruegel's work is steeped in popular imagery and popular thought in a way that is without parallel in the art of either Van Eyck or Rubens. If a detail in a Bruegel design is difficult, or impossible, to explain (and many are: the literature on him is often very learned), this is not because the artist was appealing to the erudition of his public but because the

Fig. 5
Landscape with the Parable of the Sower

PANEL, 74 × 102 CM (29⅛ × 40⅛ INS). 1557. SAN DIEGO, CALIFORNIA, TIMKEN ART GALLERY, PUTNAM FOUNDATION

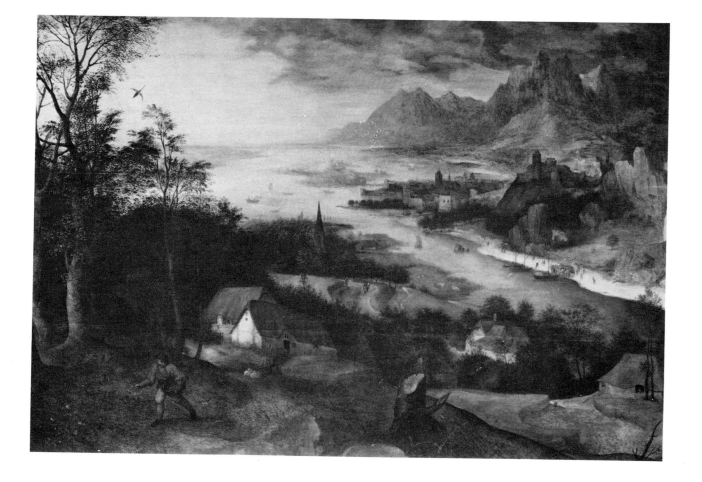

image represents an idea, a proverb or even a turn of phrase that —
like many a reference in Shakespeare, or in old ballads — has long
since passed out of common usage.

The principal standards by which Bruegel's contemporaries
judged his work were diversity of incident and accuracy of detail,
and Carel van Mander rightly claimed that Bruegel excelled in
both. The variety of incident is self-evident, although sixteenth-
century values need to be taken into account if it is to be fully
savoured. In an age when books, like education, were scarce and
when there were no equivalents to the modern media of cinema,
television and newspapers, paintings and prints had to satisfy, to a
greater degree, that craving for information which is universal and
which at root often amounts to no more than a desire to see one's
own existence confirmed by the example of others. *The Procession
to Calvary* (Plate 17) originally belonged (together with fifteen
other Bruegels) to an Antwerp merchant, Niclaes Jonghelinck, and
one can imagine him returning time and time again to study its
wealth of detail and perhaps even thinking, as he studied the lower
left area of the painting, that he had never before seen so convinc-
ing a portrayal of a man running. This passion for facts was by no

Fig. 6
The Adoration of the Kings in the
Snow

PANEL, 35 × 55 CM (13¾ × 21⅝ INS). 1567.
WINTERTHUR, DR OSKAR REINHART
COLLECTION

13

means confined to paintings and engravings; it was part of the spirit of the age, and found an eloquent expression in the cabinets of curiosities that were a pride of ruling families, and in the activities of Bruegel's friends, such as Ortelius, one of the greatest geographers of his time, who, in the very same year as *The Procession to Calvary* was painted, completed a *mappemonde*; and Plantin, the Antwerp printer who during the same period was planning the *Biblia polyglotta*, designed to fix the original text of the Old and New Testaments on a scientific basis. The same spirit permeates Bruegel's *Children's Games* (Plate 5), which now seems among his least attractive pictures precisely because the demands of a 'catalogue' have been allowed to override more pressing formal considerations.

There was an equally ready market for pictures and prints that stressed the diversity of nature and foreign lands, about which people might have heard but had little chance of seeing for themselves. In a world where travel was slow, dangerous, uncomfortable and extremely expensive, the traveller's tale was something to conjure with: and as he gazed at Bruegel's great winter landscape (Plate 23), as his eyes followed the hunters over the crest of the snow-covered hill, across the lakes dotted with skaters, past the slow, creaking cart and on through the village, over the humpbacked bridge and through the fields to the ice-locked sea, it is difficult to believe that even the most sophisticated visitor at Niclaes Jonghelinck's house did not enjoy the vicarious sensation of making a journey. How much more readily humbler purchasers of the prints must have succumbed to the spell as they examined, inch by inch, Bruegel's world in miniature. 'Nothing more in Art or Nature', we find Edward Norgate writing early in the seventeenth century, 'affords soe great variety and beauty as beholding the farre distant Mountains and strange situation of ancient Castles mounted on almost inaccessible Rocks' — a remark that might well have been inspired by one of Bruegel's own prints or knowledge of a painting such as *The Gloomy Day* (Plate 26 and detail on Plate 29).

These landscapes must often have been collected as we accumulate picture postcards today, and were judged less as 'works of art' than as evidence of the abundance and variety of the natural world. The spirit in which they were brought together is perhaps suggested by a small, early seventeenth-century panelled room in Rosenborg Castle, Christian IV's summer residence in Copenhagen. Let into the panelling, in three rows, one above the other, are a whole series of small late sixteenth- and early seventeenth-century Dutch and Flemish pictures that include an early copy of Bruegel's *Winter Landscape with Skaters and a Bird-Trap* (Fig. 7).

But this richness of incident in Bruegel's work is not only an

Fig. 7
Winter Landscape with Skaters
and a Bird-Trap

PANEL, 38 × 56 CM (15 × 22 INS). 1565.
BRUSSELS, MUSEES ROYAUX DES BEAUX-
ARTS (DELPORTE COLLECTION)

historical phenomenon that has lost its power to move us. It is an abiding source of pleasure. Quite apart from their other qualities, Bruegel's paintings and prints are extremely entertaining. They are fun to look at.

The accuracy of Bruegel's rendering of detail may also seem self-evident; but it is perhaps in greater need of comment in the light of contemporary art than the wealth of incident in his work.

Although Bruegel became a supreme master of figure painting and landscape, it was as a delineator of the natural scene that he began his career. The landscape paintings most admired in the Netherlands during the 1540s, when Bruegel was growing up and when he would have been particularly receptive to external impressions, were of a fantastic kind, in a style developed primarily by Joachim Patinir (active 1515; died not later than 1524). Its chief characteristics are a high viewpoint; great areas of land and sea depicted with microscopic precision; and an implicit appeal to the spectator to believe that he has been taken up into a high place to be shown the kingdoms of the earth.

Bruegel adopted the compositional methods of Patinir and his

followers very directly but still somewhat tentatively in such early paintings as the 1553 *Landscape with Christ appearing to the Apostles at the Sea of Tiberias* (Private Collection), and with increasing assurance in the 1560s, when he applied the system of a high viewpoint, with space sweeping away to a distant horizon, in figure subjects (Plates 10, 15, 17, 38, 39, 49) as well as in the great landscapes (Plates 23, 26, 34). Patinir's 'world landscapes', as they have been aptly called, are certainly charming; but it must be admitted that they lack any high degree of visual conviction. The vision has clear epic implications but dwindles, for lack of convincing factual support, into a toy-scape. Bruegel, on the other hand, makes the system work, absolutely, by virtue of the quality and conviction of his detail.

At the same time, the seeming accuracy of the parts in Bruegel's work should not blind one to the artifice of the whole. *The Hunters in the Snow* (Plate 23) might well be taken for a view of Flanders in the grip of winter. This is not the case. The flat fields and small hamlets in the middle of the picture, proper to the Netherlands, are combined with the snow-covered mountains of Switzerland that Bruegel had drawn in the early 1550s. *The Hunters in the Snow, The Gloomy Day* (Plate 26) or *The Return of the Herd* (Plate 34) are as much made up of improbably reconciled parts as any scene by Patinir, Jan Matsys, Herri met de Bles or other sixteenth-century landscape specialists. Even the high viewpoint with figures in the foreground disappearing over the brow of a hill is a mannerist pictorial convention of the time and can be traced back, through Netherlandish paintings such as Jan van Scorel's *Christ's Entry into Jerusalem* (Utrecht, Centraal Museum), to *The Story of the Flood* on the Sistine Ceiling.

It does not take very long to realize that there is a central contradiction in Bruegel's art, a dichotomy between the artificial, conceptual approach to the design as a whole and the naturalistic treatment of the details. These two modes of seeing are implicit in his drawings, which, apart from the finished, preparatory studies for prints, fall into two distinct groups: the landscapes seen from a distance, and the sketches of peasants observed close to and often inscribed *naer het leven* (from the life) with the same pride as Van Eyck painted the words *Johannes de eyck fuit hic* (Jan van Eyck was here) on the wall in the portrait of the Arnolfinis.

But contradictions, with great artists, do not weaken their art; they become points of tension that generate power. The wide framework and the suggestion that we are looking at an entire world give Bruegel's figures and groups a precise and essential part of their visual eloquence. 'Everyman' is more touching when he can be seen to act out his life in a context. The very scope and

breadth of the vision also has a resonance of its own: the windy spaces in that harsh paradigm of winter, *The Gloomy Day* (Plate 26), affect the senses like some great Shakespearean image:

> *And blown with restless violence round about*
> *The pendant world.*

However, the people, groups and incidents observed *naer het leven* give these epic compositions their humanity and conviction. The small scale of the figures establishes, by contrast with the space they inhabit, the frailty of the human species, and it is this suggestion of frailty which counteracts the brutishness and pessimism of Bruegel's point of view and is partly what makes these great paintings so profoundly moving. They would not be so moving, however, if they were not so well observed. Bruegel's powers of delineation — his ability to draw ordinary people as they are, to pin down, with economy and ease, exactly how they stand and walk and gesticulate — were masterly, and impart an almost documentary character to scenes like *The Fight between Carnival and Lent* (Plate 2).

Pieter Bruegel had a literal mind. And it was this literalness, a tendency to see a great many trees, each clearly defined and separate, before he saw the wood, that enabled him — quite unconsciously — to avoid the pretentious, rhetorical elements implicit in the mannerist compositional schemes that he adopted. It was also this literal cast of mind, combined with his rare capacity for visual invention (in a reincarnation Bruegel might well have been a great comedian in silent films), which made his designs so well suited to reproduction as popular prints.

Commissioned to revive the Bosch idiom, it is hardly surprising to find that Bruegel borrowed and adapted a number of its most prominent features. The most important, a development of the way in which he was already organizing his landscapes, was the idea that a given theme was precisely that, a theme on which an infinite number of variations could be played, each episode, each group of figures being set down, side by side, on a receding stage. This method of composition, apparent in such typical Bosch designs as *The Garden of Delights* (Fig. 8) and *The Hay Wain* (both the original paintings are now in the Prado, Madrid), Bruegel used at first with little finesse. In the *Children's Games* (Plate 5) the perspective is too rigid and the disposition of the groups monotonous. By degrees, however, he learned how to set down his figures more naturally in space less rudely constructed. In *The Triumph of Death* (Plate 10) the composition is organized round a diagonal which runs from top left to bottom right, on the same principle as the *Children's Games*; but how much more subtle the

arrangement has become. Instead of draining the scene of life, as it does in the earlier picture, the strong diagonal now gives an underlying visual support to the great quantity of details in which the painting abounds.

Bruegel also learned from Bosch how to achieve disturbing and often horrific effects by increasing the scale of certain key figures in a design — such as 'Mad Meg' and the Tempter, with the symbolic ship on his back, in *'Dulle Griet'* (Plate 4) — as well as a method of creating fiendish monsters by combining features from different animals, birds and reptiles in one alarming body. *The Fall of the Rebel Angels* (Plate 7), one of Bruegel's last paintings in this genre, is a particularly brilliant example. After this date he preferred to use more straightforward imagery.

Bruegel's literalness of mind also helps to explain the extraordinary degree to which his works — especially the paintings — have retained their aesthetic vitality and moral force. Little is known about Bruegel himself, but it is hard to imagine that he was an 'intellectual' artist, constantly examining his own intentions and over-aware of what he might do, of what he could do or of what he was expected to do. The paintings, drawings and prints never convey an impression of executive energies dissipated through mental speculation, as is the case with Leonardo da Vinci. Bruegel worked in a practical fashion, completing his pictures, as he completed many of his drawings, down to the last stroke. He was not in the habit of concentrating his efforts on the most important figures in a composition, so that in all his paintings are to be found the most exquisitely realized details, just as in Shakespeare superb lines are given to quite minor characters. On the extreme left of *The Procession to Calvary* (Plate 17), for example, there is a man with a heavy basket on his arm passing two women, one of whom carries a large pitcher on her head. The group is not important, it is tucked away at the side, and yet those figures, so vivid and rich in life, are drawn with a steely precision and economy of which Degas would have been proud. It is impossible to study Bruegel's paintings for long and not be moved by the sheer generosity of his talent.

The way in which Bruegel approaches a theme can be equally literal. Raphael's famous interpretation of *Christ Carrying the Cross* (Fig. 9) has a small number of timeless, idealized figures, conceived on a large scale and shown in close-up. There could hardly be a greater contrast than Bruegel's panel in Vienna (Plates 17–20). Christ here is all but lost amid the crowds which stream up the hill to watch the death of the Saviour just as if they were on their way to a contemporary execution. It is precisely this elimination of the traditional weight of significance which helps to create a new depth of feeling. Bruegel goes even further than that.

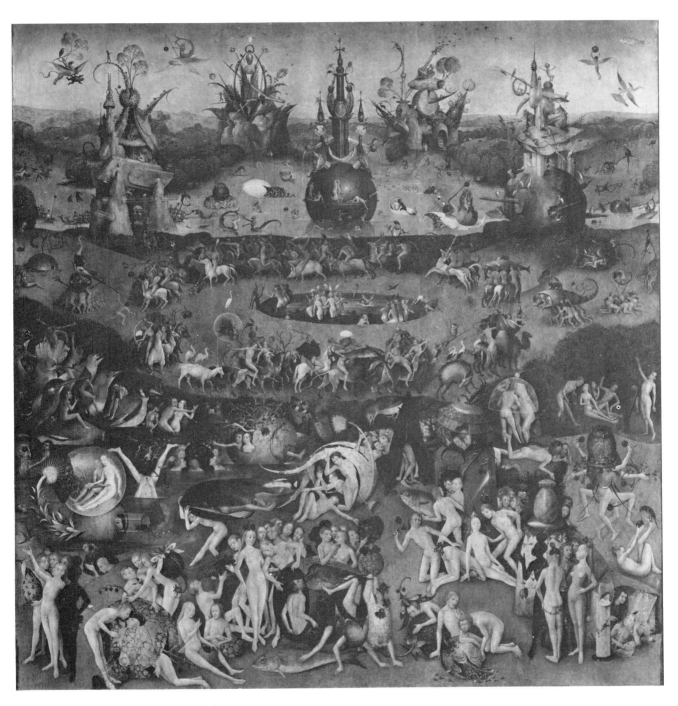

Fig. 8
HIERONYMOUS BOSCH
The Garden of Earthly Delights

CENTRE PANEL OF THE TRIPTYCH. PANEL, HEIGHT 220 CM (86⅝ INS). MADRID, PRADO

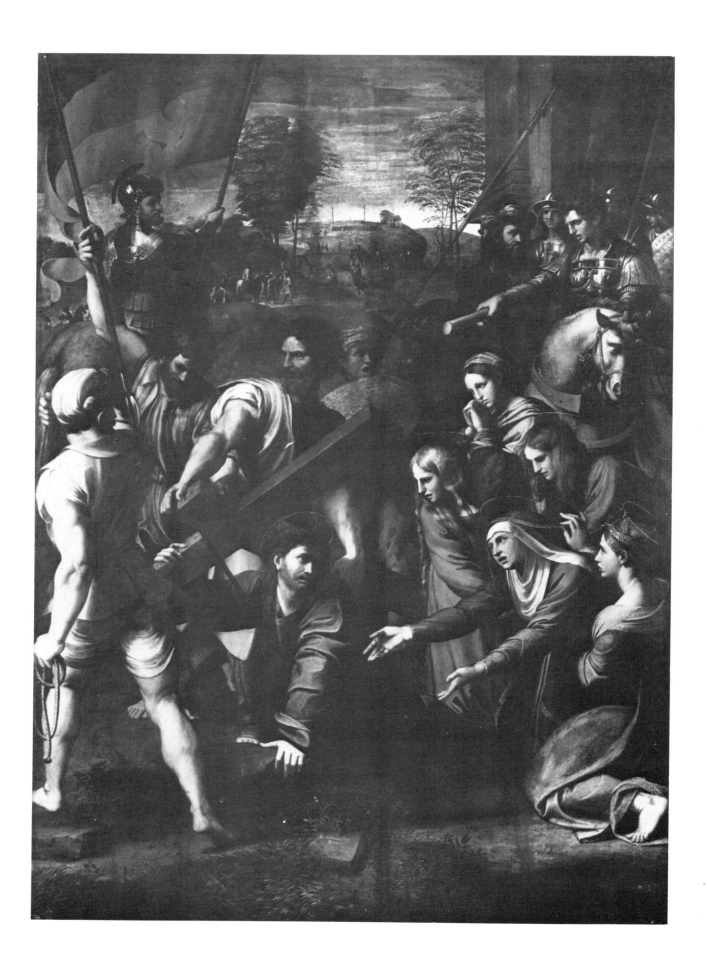

In the lower left area of the picture, Simon of Cyrene is being coerced by the soldiers into helping Christ carry His Cross (Fig. 10). He does not want to perform this simple act of mercy, and is supported by his wife, who tries to fend off the troops. And yet, prominent at her waist, there is a rosary. That this scathing visual comment on hypocritical Christianity can be incorporated in a scene illustrating one of the key events on which Christianity itself was based reveals both the pessimism and the independence of Bruegel's point of view. No church would have sanctioned such a detail in an altarpiece. And the manner in which it is done shows Bruegel's subtlety as an artist, evident in the way he has taken advantage of his own naturalistic, anachronistic style. Had he used an idealizing classical idiom and Roman draperies, consonant with the Ancient World, it would have been impossible to make the point.

It is the unnerving freshness of Bruegel's response to scriptural and allegorical subjects that gives his interpretations their core of harsh, even sometimes cruel, vitality. In Christian art, the death of

Fig. 9
RAPHAEL
Christ Carrying the Cross

TRANSFERRED FROM WOOD TO CANVAS,
318 × 229 CM (124¼ × 90 INS). MADRID,
PRADO

Fig. 10
Detail from 'The Procession to Calvary'

PANEL, 1564. VIENNA,
KUNSTHISTORISCHES MUSEUM

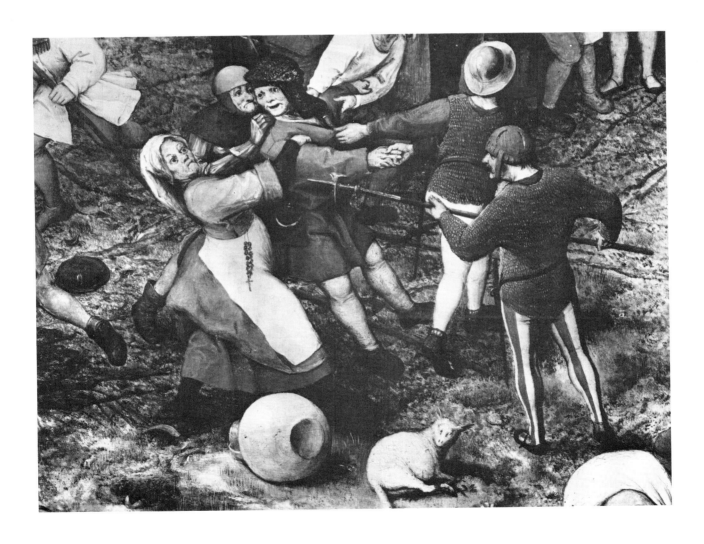

the Virgin Mary often becomes a comforting and upholstered piece of hagiography. Bruegel's version (Plate 22), painted about 1564 for his friend Ortelius, is anything but that. The vision granted to St John the Evangelist, seated in a semi-trance in the lower left corner of the picture, is of a frail and seemingly timid old woman in an enormous bed, surrounded by spectral figures whose attitudes of reverence are not without hints of almost menacing fanaticism, and whose movements are more reminiscent of mice or bats hypnotized by the light than of the patriarchs, martyrs, confessors and holy virgins who according to the *Golden Legend,* which Bruegel followed, were present at the Virgin's death. But such is the strangeness and intensity of his imagination, and so magnificently painted is this small panel, that it conveys a greater sense of religious mystery, of an absolutely unique event, than any number of bland, conventionally correct images.

The theme of earthly vanity also gains immeasurably from being treated in this literal way. In *The Triumph of Death* (Plate 10) there is no element of Miltonic grandeur to soften, through its very resonance, the horror and despair: instead, an organized, mechanized army going about its professional business. Bruegel retains the painful simplicity, the disconcerting ordinariness of an attitude to death particularly prevalent in the medieval world. Anyone who has stood in front of Francesco Traini's mid-fourteenth-century fresco of *The Triumph of Death* in the Camposanto at Pisa (Fig. 25) will immediately recognize the kinship with Bruegel's painting. Sion Cent, the Welsh author of an early fifteenth-century ballad, *The Vanity of the World,* captures the spirit perfectly in his stumpy couplets:

> *Futile the frantic plotting*
> *Of weak clay, dead in a day.*

The pessimism is absolute. Bruegel strips away the last shreds of illusion about human destiny, which neither rank, faith, love nor money can reverse, and he even adds to the note of terror with touches of bitter and ironic visual humour. In the extreme bottom right-hand corner of the picture the duetting, amorous couple has unwittingly become a trio, with death playing a fiddle (Fig. 11). This is one of the sharpest, as well as one of the best, visual jokes in European art, and is on level with Hogarth and Goya at their finest.

The figure compositions that Bruegel designed for Cock were almost always of a satirical, moralizing kind, and this is the mood that characterizes most of his paintings as well. The question of form and content in Bruegel's work, the extent to which he was expressing his own feelings, and the degree to which he was exploring the obvious implications of the commission, is very

complex and does not lend itself to any easy, clear-cut explanation.

Pending the·discovery of factual evidence, all that may be done with any degree of safety is to stress the pessimism of Bruegel's outlook. The choice of theme and the treatment invariably imply a very poor view of humanity, which is variously regarded as greedy and fatuously optimistic (e.g. the print of *The Alchemist*, Fig. 12, or the painting in Munich of *The Land of Cockaigne*, Plate 41), arrogant (*The Tower of Babel*, Plate 15) and blind to true values (*The Parable of the Blind*, Plate 48, or *The Procession to Calvary*, Plate 17) — and often hypocritical into the bargain. The ways in which people chase after pleasure are seen to be as pointless as they are disgusting since all ends in death (the print of *Big Fish Eat Little Fish*, Fig. 13, or *The Triumph of Death*, Plate 10), The frailty of the human species is at all times contrasted with nature, which follows its seasonal course sublimely indifferent to man's puny activities.

Fig. 11
Detail from 'The Triumph of Death'

PANEL, C.1562. MADRID, PRADO

Fig. 12
The Alchemist

ENGRAVING, 34.3 × 44.8 CM (13½ × 17⅝ INS).
LONDON, BRITISH MUSEUM

In trying to assess the temper of Bruegel's work, however, it is also as well to bear in mind that he lived in a period of acute political and religious strife. The Netherlands were under Spanish rule and when, in 1555, Charles V abdicated in favour of his son, Philip II of Spain, the Inquisition became more stringent than it had previously been. The combination of political and religious persecution inevitably led to revolutionary outbreaks, notably those of 1567 under William of Orange. Reprisals were swift. The infamous Duke of Alba, appointed governor-general of the Netherlands in the same year, set up a notorious tribunal known as the Council of Troubles. *The Massacre of the Innocents* (Plate 38) — where the Biblical story is set in a sixteenth-century Flemish village, which is being sacked — was probably not painted with a direct political implication in mind, but there can still be little doubt that for Bruegel's contemporaries the image would have had emotive overtones that are lost to us today. It is against this tragic background that his work must be viewed. It was a terrifying time, when those who looked for guidance to the pole star of religion

would too often have seen a luminary suffused with blood. An inventive imagination, underlying realism, the capacity to record traits of behaviour accurately, a deeply pessimistic concern with the human condition — these are all important elements in Bruegel's art. And the proportions in which they appear and the skill with which they are combined help to account for its power. But these factors alone cannot explain the greatness of Bruegel's work. Seventeenth-century genre painting, after all, and eighteenth-century conversation pieces, not to mention the crowded Victorian beaches and railway stations of an artist like Frith, are all filled with realistic detail. Often a great deal of didactic information about life is presented. Yet pictures of this kind invariably lack the touch of life. What sets Bruegel apart from Frith is what differentiates a statue from a waxwork: the waxwork may be more detailed but it is not created in the light of any compelling or overriding aesthetic point of view.

It was this aesthetic awareness, this deep commitment to the intrinsic properties of colour and line, that saved Bruegel from the twin pitfalls of triviality and mere literary illustration. His appetite for detail was certainly as acute as that of any sixteenth-century

Fig. 13
Big Fish Eat Little Fish

ENGRAVING, 22.9 × 29.8 CM (9 × 11¾ INS).
LONDON, BRITISH MUSEUM

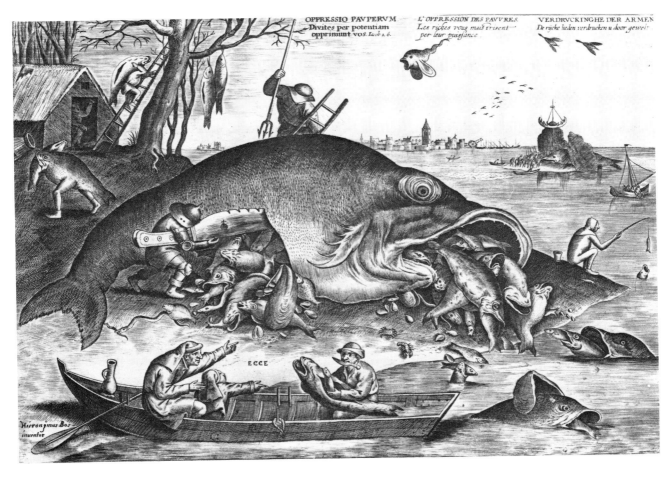

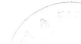

Netherlandish artist. What sets him apart, and generates a constant source of visual tension and vitality, is that this additive instinct was balanced by an equally strong feeling for simplification. Approach any of Bruegel's paintings closely and what is usually meant by the term 'detail' is often hard to find. Eyes are reduced to round holes, heads resemble footballs, bodies punched sacks of flour, while clothing is nearly always generalized. This is particularly clear in the drawing of the figures and animals in *The Return of the Herd* (Plate 34). Even the paint itself is often applied sparingly — the Virgin's robe in *The Adoration of the Magi* (Plate 21) is a revealing instance.

This refusal to stress detail and texture helped Bruegel to give the maximum emphasis to the silhouette of his forms; it was on the silhouette that he relied for many of his most telling effects. Training and association with Hieronymus Cock may perhaps explain this preference. As in the case of Daumier, Bruegel's experiences as a print-designer, working in black and white without the possibility of colour, must have increased his capacity to think if not exclusively, at least primarily, in terms of line and outline. And certainly what is memorable about Bruegel's figures and groups are not the faces or the buttons and hair but overall shapes, the flat pattern formed by the outlines of the figure. *The Hunters in the Snow* (Plate 23) has achieved enormous popularity largely for this very reason: the visual impact of the striding figures, the dogs and the receding tree-trunks is as instantaneous and clear-cut as in a poster by Toulouse-Lautrec. The horseman in yellow on the extreme right of *The Conversion of St Paul* (Plate 39) also has a rich heraldic simplicity that had hardly been seen in European art since Uccello. Like Degas, Bruegel was evidently fond of figure-shapes that are formally complete in themselves; both loved the visually self-contained form; and it is noticeable how often Bruegel chooses to show his figures from the back, which presents a much more simplified shape. It is this sense of shape, this ability to find for every idea, every observed fragment of the natural scene, both animate and inanimate, a striking and memorable pictorial equivalent, that is the crown of Bruegel's achievement as an artist. Everywhere you look in his paintings, drawings and prints you will find his acute sensitivity at work, breathing visual life into a looped-up curtain (Plate 22), the roofs of the town nestling round the base of *The Tower of Babel* (Plate 15), pies on an improvised tray (Plate 42) or the tracery of branches that in *The Gloomy Day* (Plate 26) stands out against the louring sky. Indeed, this feeling for shapes was so strong that it sometimes forced him into a purely two-dimensional emphasis. The surcoat of the kneeling king in *The Adoration of the Magi* (Plate 21) is not painted as if it were

being worn, but as if it were lying flat. And in *The Death of the Virgin* (Plate 22), note how the back-rest of the chair is made parallel with the picture surface; it does not project in a way that the perspective of the base would suggest. But had it been drawn 'properly', the chair would have become obtrusive. Like all good artists, Bruegel was absolutely discriminating in his attitude to 'realism'.

Bruegel himself was undoubtedly aware of the emotive power of the silhouette. In several of his most important pictures he used a winter setting (e.g. Plate 38), so that the figures might appear even more striking against the prevailing whiteness of the snow. Concentration on outline had another advantage. It was a useful method of emphasizing an aspect of life in which Bruegel was particularly interested: motion. Bruegel is one of the great delineators of movement in European art, with the result that the world he paints is ceaselessly busy. Since he held a pessimistic view of life, most of the people in his work who are perfectly still invariably turn out to be bloated with food, stupefied with drink, or dead.

It was this simplification of form, rather than its idealized character, which attracted Bruegel to the works of Italian art that he saw and studied, and by which he was influenced after his move to Brussels in 1563. In many of his later paintings (Plates 47, 42, 45, 48, 50) the figures are large, they quite dominate the scene, but their only real connection with the Italian Renaissance style lies in their massive simplicity. What has changed is not the strategy, but the tactics. To appreciate this fully, it is necessary only to compare *The Parable of the Blind* (Plate 48) — relentlessly pathetic, even harrowing, in its effect — with a Renaissance work that Bruegel may well have known, Raphael's cartoon of *The Blinding of Elymas* (Fig. 14), which is carried out in an idealizing, classical idiom so strong that even the figure of the false prophet and magician, Elymas, is invested with a tincture of genuine nobility.

Bruegel's world is lavishly filled. But this prodigality is neither heedless nor a sign of weakness. In all his work, with its gaunt mediaeval overtones and suggestion of a magpie's teeming nest, can be traced a purely aesthetic sensibility of the highest order, a knowledge, ruthless in the severity of its application, of what will and will not work *visually*. At the same time, Bruegel is the least self-indulgent of artists: his pictures have a subject, which he respects, and which he does not distort in the interests of virtuosity. Pieter Bruegel cannot be looked upon as a moralist who also happened to paint, any more than he can be regarded as a painter tragically committed to literary illustration. It is precisely from this indivisible unity that both the power and diversity of his art spring. No sooner has the purely visual pleasure Bruegel's

Fig. 14
RAPHAEL
The Blinding of Elymas

CARTOON FOR A TAPESTRY, WIDTH 5.79M
(19 FT). LONDON, VICTORIA AND ALBERT
MUSEUM (ON LOAN FROM HER MAJESTY
THE QUEEN)

works afford made itself felt, than the very same lines, shapes and colours through which this visual pleasure is conveyed translate themselves into forms of thought, portents, even warnings, that speed to the vaults of the mind, where they linger and echo. Like a hieroglyphic cypher, Bruegel's figures and groups, even whole paintings, have a significant meaning and a telling visual form that coincide exactly. That is why, on entering the room in the Vienna Gallery where so many of his finest works are displayed, the first, overwhelming impression is not of quaintness, nor even of beauty — though the paintings are beautiful enough — but of urgency: extraordinary urgency.

# Outline biography

**1525–30** Pieter Bruegel likely to have been born in this period; actual date unknown. Until 1559 he spelt his name 'Brueghel', then as 'Bruegel'. The reasons for this change are not known. According to Van Mander, Bruegel was apprenticed to Pieter Coeck van Aelst, whose daughter he was later to marry. The date of the apprenticeship is unknown, though it was obviously well before December 1550, the date of Coeck's death.

**1551** Becomes a member of the Painters' Guild in Antwerp.

**1552** Travels in Italy; there is evidence to show that he was in Reggio (Calabria), Messina, Palermo, and Naples.

**1553** In Rome, where he meets the miniaturist, Giulio Clovio, for whom he paints a small-scale picture of the *Tower of Babel* on ivory, and a *View of Lyons* (France) in water-colours and probably on linen, a technique he may have learned from Pieter Coeck van Aelst's wife, who was a specialist in this medium. Bruegel also painted a picture in collaboration with Clovio. All these works are now lost. On his return journey to the Netherlands, Bruegel evidently spends some time in Switzerland, where he makes many drawings of the Alps. The date of his return is not known, but Fritz Grossmann has suggested that it must have been some time between the spring and autumn of 1554. The earliest known painting to carry a date is from this year: the *Landscape with Christ Appearing to the Apostles at the Sea of Tiberias* (Private Collection).

**1555** Back in Antwerp and working for Hieronymus Cock, the engraver and publisher of prints. The only surviving drawing by Bruegel for the *Large Landscapes*, a series of engravings issued by Cock, is dated to this year.

**1556** At work on figure compositions. For instance, the original drawing for the well-known print, *Big Fish Eat Little Fish* (engraved by Van der Heyden in 1557), is dated to this year.

**1557** Date of the first of the paintings of the post-Italian period: the *Parable of the Sower* (San Diego; Fig. 5). For the rest of his career, Bruegel is busy both as a painter and as a designer of prints; after about 1562, however, he seems to devote more time to painting.

**1559** *The Fight Between Carnival and Lent* (Plate 2) and *The Netherlandish Proverbs* (Berlin; Fig. 19).

**1560** *Children's Games* (Plate 5).

**1562** *The Suicide of Saul* (Plate 13), *The Fall of the Rebel Angels* (Brussels; Fig. 22), '*Dulle Griet*' *(Mad Meg)* (Plate 8). Probably visits Amsterdam.

**1563** Marries Mayken, the daughter of Pieter Coeck and Mayken Verhulst, in Brussels, where he now settles. Paints *The Tower of Babel* (Plate 15) and *The Flight into Egypt* (London, Courtauld Institute Galleries), the latter painted probably for, and certainly owned by, Cardinal Antoine Perrenot de Granvelle, a powerful Catholic of the day.

**1564** *The Adoration of the Magi* (Plate 21) and *The Procession to Calvary* (Plate 17), which is painted for Niclaes Jonghelinck, who lives in Antwerp and who comes to own no less than sixteen works by Bruegel. Birth of his elder son, Pieter, who also becomes a painter (dies 1638).

**1565** *Christ and the Woman taken in Adultery* (London, Courtauld Institute Galleries), *Winter Landscape with Skaters and a Bird-Trap* (Brussels, Musées Royaux des Beaux-Arts, Delporte Collection), and the series of the *Months* (Plates 23, 26, 30, 33) painted for Jonghelinck.

**1566** *The Numbering at Bethlehem* (Brussels; Fig. 33), *The Wedding Dance in the Open Air* (Detroit; Fig. 37), *The Sermon of St John the Baptist* (Budapest; Fig. 29).

**1567** *The Adoration of the Kings in the Snow* (Winterthur, Reinhart Bequest; Fig. 6), *The Land of Cockaigne* (Munich; Plate 41).

**1568** Birth of second son, Jan, who also becomes a

painter, chiefly active in Antwerp (dies 1625). *The Cripples* (Paris), *The Parable of the Blind* (Plate 48), *The Misanthrope* (Plate 50), *The Peasant and the Birdnester* (Plate 47) and *The Magpie on the Gallows* (Plate 49).

**1509** 9 September: Bruegel dies, and is buried in Notre Dame de la Chapelle, Brussels.

**1578** Death of Mayken Bruegel.

The author is indebted for much of the information quoted above to Fritz Grossmann's invaluable study of the artist, first published in 1955 (third edition, 1973).

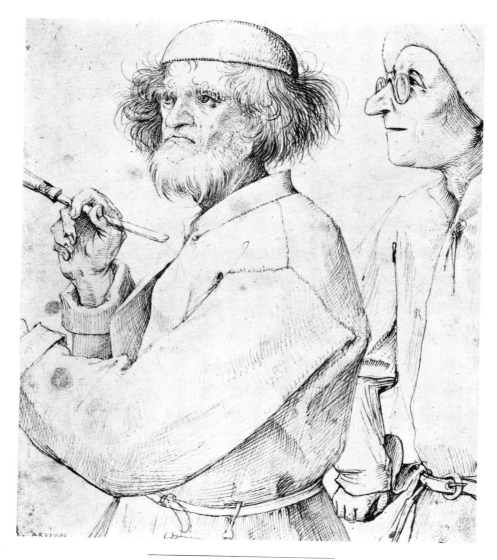

Fig. 15
The Painter and the Connoisseur

BROWN INK, 25 × 21.6 CM (9⅞ × 8½ INS). VIENNA, ALBERTINA

# List of Illustrations

## Colour Plates

1. Detail from 'Landscape with the Fall of Icarus'
   TRANSFERRED FROM PANEL TO CANVAS, C. 1555. BRUSSELS, MUSEES ROYAUX DES BEAUX-ARTS

2. The Fight between Carnival and Lent
   PANEL, 1559. VIENNA, KUNSTHISTORISCHES MUSEUM

3. Detail from 'The Fight between Carnival and Lent'
   PANEL, 1559. VIENNA, KUNSTHISTORISCHES MUSEUM

4. Detail from 'The Netherlandish Proverbs'
   PANEL, 1559. BERLIN-DAHLEM, STAATLICHE MUSEEN

5. Children's Games
   PANEL, 1560. VIENNA, KUNSTHISTORISCHES MUSEUM

6. Detail from 'Children's Games'
   PANEL, 1560. VIENNA, KUNSTHISTORISCHES MUSEUM

7. Detail from 'The Fall of the Rebel Angels'
   PANEL, 1562. BRUSSELS, MUSEES ROYAUX DES BEAUX-ARTS

8. 'Dulle Griet' (Mad Meg)
   PANEL, C. 1562. ANTWERP, MUSEUM MAYER VAN DEN BERGH

9. Detail from 'Dulle Griet' (Mad Meg)
   PANEL, C.1562. ANTWERP, MUSEUM MAYER VAN DEN BERGH

10. The Triumph of Death
    PANEL, C. 1562. MADRID, PRADO

11. Detail from 'The Triumph of Death'
    PANEL, C. 1562. MADRID, PRADO

12. Detail from 'The Triumph of Death'
    PANEL. C. 1562. MADRID, PRADO

13. The Suicide of Saul
    PANEL, 1562. VIENNA, KUNSTHISTORISCHES MUSEUM

14. Detail from 'The Suicide of Saul'
    PANEL, 1562. VIENNA, KUNSTHISTORISCHES MUSEUM

15. The Tower of Babel
    PANEL, 1563. VIENNA, KUNSTHISTORISCHES MUSEUM

16. Detail from 'The Tower of Babel'
    PANEL, 1563. VIENNA, KUNSTHISTORISCHES MUSEUM

17. The Procession to Calvary
    PANEL, 1564. VIENNA, KUNSTHISTORISCHES MUSEUM

18. Detail from 'The Procession to Calvary'
    PANEL, 1564. VIENNA, KUNSTHISTORISCHES MUSEUM

19. Detail from 'The Procession to Calvary'
    PANEL, 1564. VIENNA, KUNSTHISTORISCHES MUSEUM

20. Detail from 'The Procession to Calvary'
    PANEL, 1564. VIENNA, KUNSTHISTORISCHES MUSEUM

21. The Adoration of the Magi
    PANEL, 1564. LONDON, NATIONAL GALLERY

22. The Death of the Virgin
    PANEL, C. 1564. BANBURY, UPTON HOUSE (NATIONAL TRUST)

23. The Hunters in the Snow (January)
    PANEL, 1565. VIENNA, KUNSTHISTORISCHES MUSEUM

24. Detail from 'The Hunters in the Snow' (January)
    PANEL, 1565. VIENNA, KUNSTHISTORISCHES MUSEUM

25. Detail from 'The Hunters in the Snow' (January)
    PANEL, 1565. VIENNA, KUNSTHISTORISCHES MUSEUM

26. The Gloomy Day (February)
    PANEL, 1565. VIENNA, KUNSTHISTORISCHES MUSEUM

27. Detail from 'The Gloomy Day' (February)
    PANEL, 1565. VIENNA, KUNSTHISTORISCHES MUSEUM

28. Detail from 'The Gloomy Day' (February)
    PANEL, 1565. VIENNA, KUNSTHISTORISCHES MUSEUM

29. Detail from 'The Gloomy Day' (February)
    PANEL, 1565. VIENNA, KUNSTHISTORISCHES MUSEUM

30. Haymaking (July)
    PANEL, 1565, PRAGUE, NATIONAL GALLERY

31. Detail from 'Haymaking' (July)
    PANEL, 1565. PRAGUE, NATIONAL GALLERY

32. Detail from 'Haymaking' (July)
    PANEL, 1565. PRAGUE, NATIONAL GALLERY

33. The Corn Harvest (August)
    PANEL, 1565. NEW YORK, METROPOLITAN MUSEUM OF ART

34. The Return of the Herd (November)
    PANEL, 1565. VIENNA, KUNSTHISTORISCHES MUSEUM

35. Detail from 'The Return of the Herd' (November)
    PANEL, 1565. VIENNA, KUNSTHISTORISCHES MUSEUM

36. Detail from 'The Return of the Herd'
    PANEL, 1565. VIENNA, KUNSTHISTORISCHES MUSEUM

37. Detail from 'The Numbering at Bethlehem'
    PANEL, 1566. BRUSSELS, MUSEES ROYAUX DES BEAUX-ARTS

38. The Massacre of the Innocents
    PANEL, C. 156X. VIENNA, KUNSTHISTORISCHES MUSEUM

39. The Conversion of St Paul
    PANEL, 1567. VIENNA, KUNSTHISTORISCHES MUSEUM

40. Detail from 'The Conversion of St Paul'
PANEL, 1567. VIENNA, KUNSTHISTORISCHES MUSEUM

41. Detail from the 'The Land of Cockaigne'
PANEL, 1567. MUNICH, ALTE PINAKOTHEK

42. The Peasant Wedding
PANEL, C. 1567. VIENNA, KUNSTHISTORISCHES MUSEUM

43. Detail from 'The Peasant Wedding'
PANEL, C. 1567. VIENNA, KUNSTHISTORISCHES MUSEUM

44. Detail from 'The Peasant Wedding'
PANEL, C. 1567. VIENNA, KUNSTHISTORISCHES MUSEUM

45. The Peasant Dance
PANEL, C. 1567. VIENNA, KUNSTHISTORISCHES MUSEUM

46. Detail from 'The Peasant Dance'
PANEL, C. 1567. VIENNA, KUNSTHISTORISCHES MUSEUM

47. The Peasant and the Birdnester
PANEL, 1568. VIENNA, KUNSTHISTORISCHES MUSEUM

48. The Parable of the Blind
CANVAS, 1568. NAPLES, MUSEO NAZIONALE

49. Detail from 'The Magpie on the Gallows'
PANEL, 1568. DARMSTADT, HESSISCHES LANDESMUSEUM

50. The Misanthrope
CANVAS, 1568. NAPLES, MUSEO NAZIONALE

51. Storm at Sea
PANEL, C. 1569. VIENNA, KUNSTHISTORISCHES MUSEUM

# Text Figures

1. Portrait of Bruegel
ENGRAVING FROM DOMINICUS LAMPSONIUS, 'PICTORUM ALIQUOT CELEBRIUM GERMANIAE INFERIORIS EFFIGIES', ANTWERP, 1572

2. Solicitudo Rustica (Country Concerns)
PREPARATORY DRAWING FOR AN ENGRAVING IN THE 'LARGE LANDSCAPE' SERIES. PEN AND BROWN INK OVER BLACK CHALK. LONDON, BRITISH MUSEUM

3. Solicitudo Rustica (Country Concerns)
ENGRAVING BY HIERONYMOUS COCK AFTER BRUEGEL'S DRAWING. LONDON, BRITISH MUSEUM

4. Superbia (Pride)
ENGRAVING IN THE 'SEVEN DEADLY SINS' SERIES. LONDON, BRITISH MUSEUM

5. Landscape with the Parable of the Sower
PANEL, 1557. SAN DIEGO, CALIFORNIA, TIMKEN ART GALLERY

6. The Adoration of the Kings in the Snow
PANEL, 1567. WINTERTHUR, DR OSKAR REINHART COLLECTION

7. Winter Landscape with Skaters and a Bird-Trap
PANEL, 1565. BRUSSELS, MUSEES ROYAUX DES BEAUX-ARTS (DELPORTE COLLECTION)

8. Hieronymous Bosch: The Garden of Earthly Delights
CENTRE PANEL OF THE TRIPTYCH. OIL ON PANEL, MADRID, PRADO

9. Raphael: Christ Carrying the Cross
TRANSFERRED FROM WOOD TO CANVAS. MADRID, PRADO

10. Detail from 'The Procession to Calvary'
PANEL, 1564. VIENNA, KUNSTHISTORISCHES MUSEUM

11. Detail from 'The Triumph of Death'
PANEL, C. 1562. MADRID, PRADO

12. The Alchemist
ENGRAVING. LONDON, BRITISH MUSEUM

13. Big Fish Eat Little Fish
ENGRAVING. LONDON, BRITISH MUSEUM

14. Raphael: The Blinding of Elymas
CARTOON FOR A TAPESTRY. LONDON, VICTORIA AND ALBERT MUSEUM (ON LOAN FROM HER MAJESTY THE QUEEN)

15. The Painter and the Connoisseur
BROWN INK. VIENNA, ALBERTINA

# Comparative Figures

16.  **Landscape with the Fall of Icarus**
     TRANSFERRED FROM PANEL TO CANVAS. BRUSSELS, MUSEES
     ROYAUX DES BEAUX-ARTS

17.  **The Cripples**
     PANEL, 1568. PARIS, MUSEE DU LOUVRE

18.  **Detail From 'The Fight between Carnival and
     Lent'**
     PANEL, 1559. VIENNA, KUNSTHISTORISCHES MUSEUM

19.  **The Netherlandish Proverbs**
     PANEL, 1559. BERLIN-DAHLEM, STAATLICHE MUSEEN

20.  **Detail from 'Children's Games'**
     PANEL, 1560. VIENNA, KUNSTHISTORISCHES MUSEUM

21.  **Detail from 'Children's Games'**
     PANEL, 1560. VIENNA, KUNSTHISTORISCHES MUSEUM

22.  **The Fall of the Rebel Angels**
     PANEL, 1562. BRUSSELS, MUSEES ROYAUX DES BEAUX-ARTS

23.  **Detail from 'Dulle Griet' (Mad Meg)**
     PANEL, 1562. ANTWERP, MUSEUM MAYER VAN DEN BERGH

24.  **Detail from 'Dulle Griet' (Mad Meg)**
     PANEL, 1562. ANTWERP, MUSEUM MAYER VAN DEN BERGH

25.  **Francesco Traini (?): The Triumph of Death**
     FRESCO. PISA, CAMPOSANTO

26.  **Detail from 'The Triumph of Death'**
     PANEL, C.1562. MADRID, PRADO

27.  **The Tower of Babel**
     PANEL. ROTTERDAM, MUSEUM BOYMANS
     VAN BEUNINGEN

28.  **Detail from 'The Tower of Babel'**
     PANEL, 1563. VIENNA, KUNSTHISTORISCHES MUSEUM

29.  **The Sermon of St John the Baptist**
     PANEL, 1566. BUDAPEST, MUSEUM OF FINE ARTS

30.  **Detail from 'The Procession to Calvary'**
     PANEL, 1564. VIENNA, KUNSTHISTORISCHES MUSEUM

31.  **The Resurrection of Christ**
     BRUSH AND PEN DRAWING IN GRISAILLE ON PAPER ATTACHED
     TO A PANEL, C.1562. ROTTERDAM, MUSEUM BOYMANS – VAN
     BEUNINGEN

32.  **Detail from 'The Corn Harvest' (August)**
     PANEL, 1565. NEW YORK, METROPOLITAN MUSEUM OF ART

33.  **The Numbering at Bethlehem**
     PANEL, 1566. BRUSSELS, MUSEES ROYAUX DES BEAUX-ARTS

34.  **Detail from 'The Massacre of the Innocents'**
     PANEL, 1566. VIENNA, KUNSTHISTORISCHES MUSEUM

35.  **The Land of Cockaigne**
     PANEL, 1567. MUNICH, ALTE PINAKOTHEK

36.  **Gula (Gluttony)**
     ENGRAVING IN THE 'SEVEN DEADLY SINS' SERIES. LONDON,
     BRITISH MUSEUM

37.  **The Wedding Dance in the Open Air**
     PANEL, 1566. DETROIT, INSTITUTE OF ARTS

38.  **Detail from 'The Peasant Dance'**
     PANEL, C.1567. VIENNA, KUNSTHISTORISCHES MUSEUM

39.  **Detail from 'The Parable of the Blind'**
     CANVAS, 1568. NAPLES, MUSEO NAZIONALE

40.  **The Magpie on the Gallows**
     PANEL, 1568. DARMSTADT, HESSISCHES LANDESMUSEUM

41.  **Marine Landscape with a view of Antwerp**
     PEN AND BROWN INK. LONDON, COURTAULD INST. GALLS.

# Detail from 'Landscape with the Fall of Icarus'

SEE FIG. 16

This painting is generally thought to date from about 1555, soon after Bruegel had returned from Italy. It is the only picture with a mythological subject in Bruegel's painted *œuvre*. The literary source is Ovid's *Metamorphoses,* in which the poet tells the story of the great engineer Daedalus, who constructed the Labyrinth for King Minos, and his son Icarus. Icarus, over-ambitious, ignored his father's warning and flew too close to the sun, whose strength melted the wax holding his wings together. He plunged to his death in the sea; here only his legs can be seen above the water, to the far right of the painting.

The artist has followed Ovid's text accurately. The ploughman, fisherman and shepherd are all mentioned, though a curious feature is the position of the sun. Sinking, and already on the horizon, it does not fit in with Ovid's account of its position high in the sky. The motif of the peasant with the plough is given added significance by the presence of the corpse of an old man, only just visible, lying in the bushes on the left. This refers to the Flemish proverb 'No plough stops because a man dies'. The high viewpoint and the town glimpsed in the distance are recurring features of Bruegel's early landscape style.

Fig. 16
Landscape with the Fall of Icarus

TRANSFERRED FROM PANEL TO CANVAS, 73.5 × 112 CM (29 × 44⅛ INS). BRUSSELS, MUSEES ROYAUX DES BEAUX-ARTS

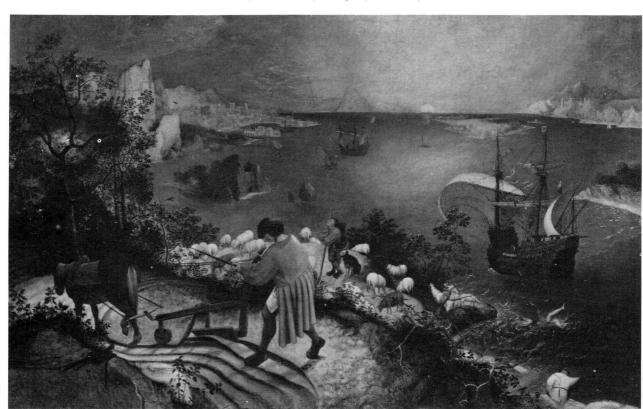

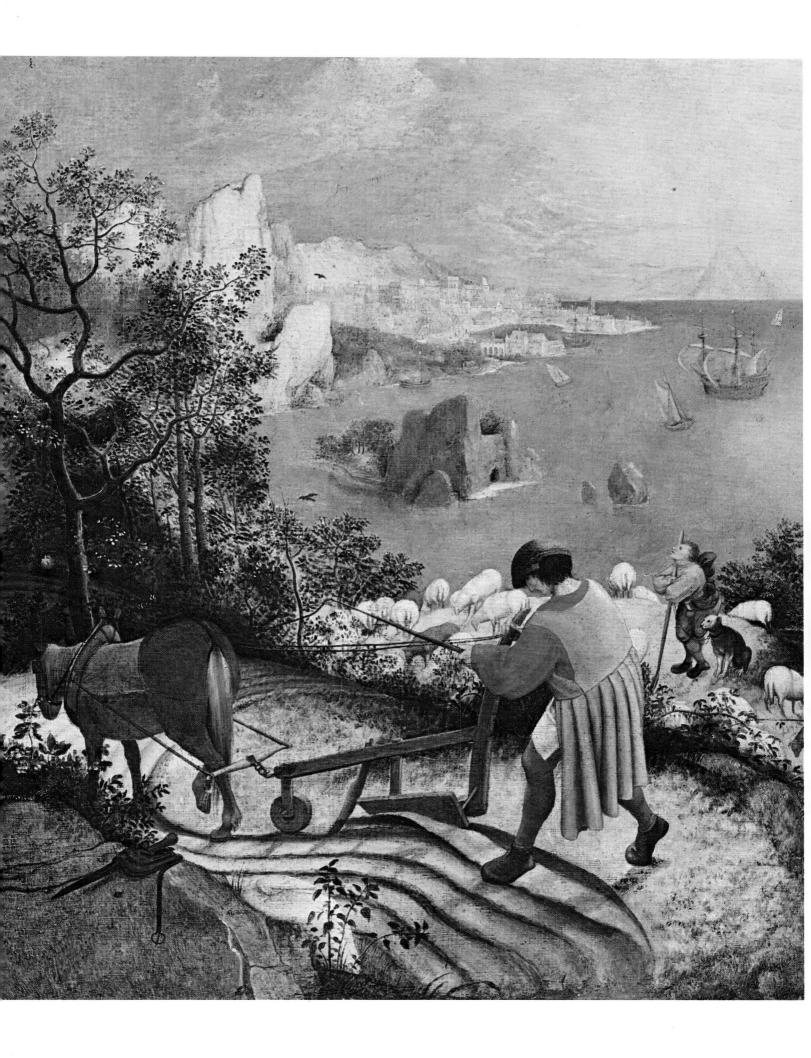

# The Fight between Carnival and Lent

PANEL, 118 × 164.5 CM (46½ × 64¾ INS). SIGNED AND DATED, 1559. VIENNA, KUNSTHISTORISCHES MUSEUM

With the *Netherlandish Proverbs* (Plate 4), also painted in 1559, this is the first in a series of allegories of human wickedness and foolishness which are based on the work of Hieronymous Bosch. The high viewpoint and the mass of small figures show strong compositional similarities to Bosch's *Garden of Earthly Delights* (Fig. 8), for example.

This painting takes as its subject the traditional annual carnival which was held in Flemish towns and villages in the week before Lent. A half-religious, half-secular festival, it provided an excuse for excesses of eating, drinking and sex; contemporary moralists condemned it as the *duivelsweek* (devil's week). Bruegel stresses the opposition between the traditional enemies, Carnival and Lent, by representing their conflict as a joust. The two adversaries — the obese Carnival, seated astride a barrel and with a spit for a tilting lance, and the thin pinched figure of Lent, seated in a cart and using a baker's shovel as her weapon — come to blows in the square of a small Flemish town.

Bruegel's mocking treatment of the figures of both Carnival and Lent has led some writers to see the painting as a satire on contemporary religion and it is certainly true that the humanist circle to which Bruegel belonged in Antwerp believed that the conflict between the Protestant (Carnival) and Catholic (Lent) churches was at the root of the troubled state of northern Europe in Bruegel's day. However, like *The Netherlandish Proverbs*, it probably has a more generalized meaning, illustrating Bruegel's belief that human activities are motivated by folly and self-seeking.

The immediate source for Bruegel's choice of the subject was an engraving by his own publisher, Hieronymous Cock, of a design by Frans Hogenberg, which had been published in the previous year, 1558. However, where Hogenberg is leadenly allegorical, Bruegel's use of naturalistic detail enlivens his composition.

Certain motifs frequently recur in Bruegel's work. The group of cripples and beggars on Carnival's side of the square, ignored by the revellers, can be seen again (with some variations) in *The Cripples* of 1568 (Fig. 17), one of the artist's last paintings.

Fig. 17
The Cripples

PANEL, 18 × 21.5 CM (7⅛ × 8½ INS). 1568. PARIS, MUSÉE DU LOUVRE

# Detail from 'The Fight between Carnival and Lent'

SEE PLATE 2

This detail shows some of the followers of Prince Carnival, dressed in extravagant costume. Among them are the pot-bellied man playing a mandolin and the man with waffles in his hatband and a mirror on his back who is throwing dice with his masked partner. On Carnival's side of the square two popular plays *Urson and Valentine* and *The Dirty Bride* are being performed. The latter — seen here in the top left-hand corner — is a farce about a poor peasant who apes the lavish weddings of the rich. Here he is seen dancing with his unkempt bride to their marriage bed, the bare earth within his rickety tent.

Fig. 18 shows the ridiculous figure of Lent — she is derived from a Boschian witch. She clutches a bunch of dead twigs, a symbol of human degradation. The playing children who follow her symbolize folly and vanity.

Fig. 18
Detail from 'The Fight between Carnival and Lent'

PANEL, 1559. VIENNA, KUNSTHISTORISCHES MUSEUM

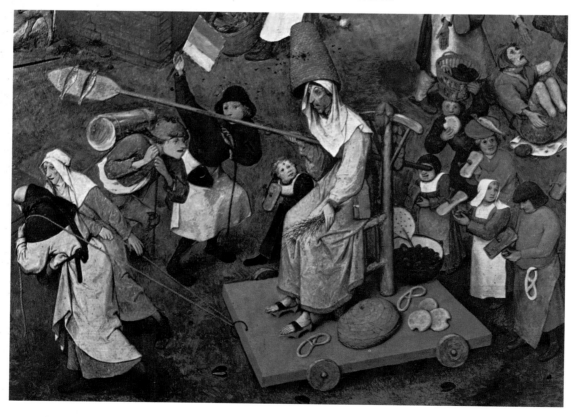

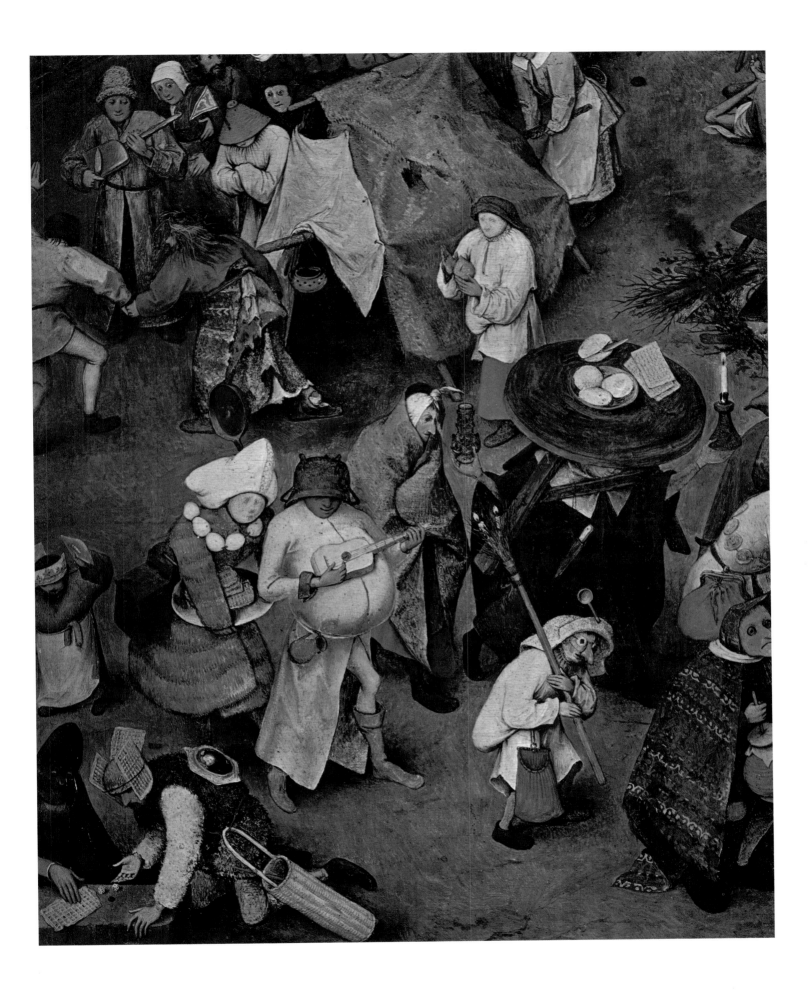

# Detail from 'The Netherlandish Proverbs'

SEE FIG. 19

Painted in the same year as the *Fight between Carnival and Lent,* this painting belongs to the group of allegorical pictures in the manner of Bosch. Although individual proverbs and groups of proverbs had been represented in Flemish art before, this is the first picture to create a whole world of them. These traditional sayings, of which there were numerous contemporary compilations, are of two principal types. Firstly, those which turn reason on its head, thereby showing the absurdity of much human behaviour; these have for their symbol the world turned upside-down, represented by the upturned orb on the house-sign on the left. The second type, which have a more serious, moralizing tone, illustrate the dangers of folly, which can lead to sin — for example, the woman who hangs a blue coat on her husband (that is, cuckolds him) and, just above, the man 'lighting candles for the devil'. Other proverbs illustrated include: 'He blocks up the well after the calf is drowned' (centre, bottom); 'One shears the sheep, another the pig' (left, bottom); 'One holds the distaff which the other spins' (that is, spreading evil gossip; centre, middle); 'The pig has been stuck through the belly' (centre, middle); 'He throws roses to the swine' (centre); 'He brings baskets of light into the daylight' (top).

Fig. 19
The Netherlandish Proverbs

PANEL, 117 × 163 CM (46 × 64⅛ INS). 1559. BERLIN-DAHLEM, STAATLICHE MUSEEN

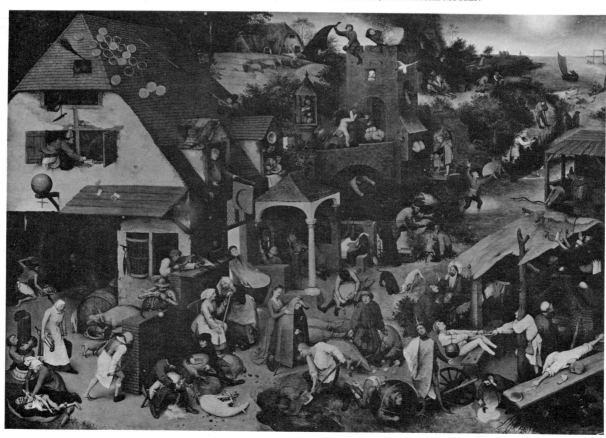

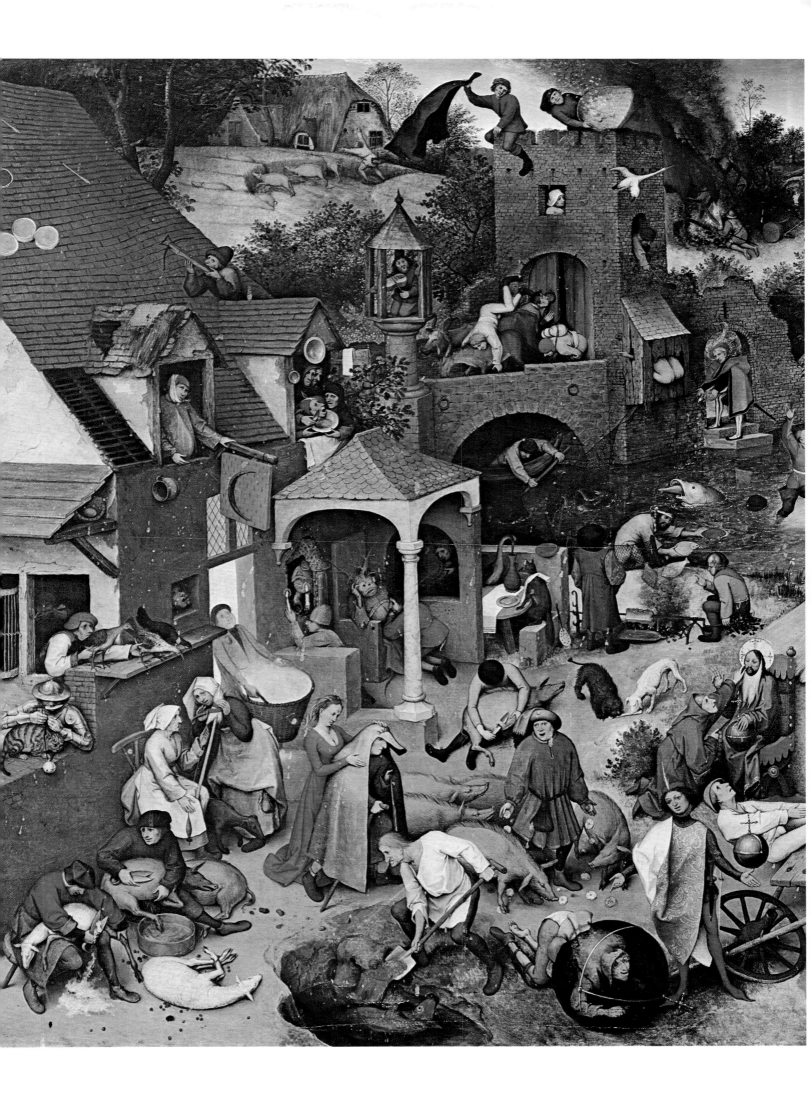

# Children's Games

PANEL, 118 × 161 CM (46½ × 63¾ INS). SIGNED AND DATED, 1560. VIENNA, KUNSTHISTORISCHES MUSEUM

This painting is mentioned for the first time by Carel van Mander in his account of Bruegel's life. It passed into the Collection of Archduke Ernst of Austria in 1594. It has been suggested that *Children's Games* was the first in a projected series of paintings representing the Ages of Man, in which it would have stood for Youth. If that was Bruegel's intention, it is unlikely that the series progressed beyond this painting, for there are no contemporary or subsequent mentions of related pictures.

The children, who range in age from toddlers to adolescents, roll hoops, walk on stilts, spin tops, ride hobby-horses, stage mock tournaments, play leap-frog and blind man's buff, perform handstands, inflate pigs' bladders and play with dolls and other toys. They have also taken over the large building that dominates the square: it may be a town hall or some other important civic building, in this way emphasizing the moral that the adults who direct civic affairs are as children in the sight of God. This crowded scene is to some extent relieved by the landscape in the top left-hand corner (Fig. 20); but even here children are bathing in the river and playing on its banks.

Fig. 20 (right)
Detail from 'Children's Games'

PANEL, 1560. VIENNA, KUNSTHISTORISCHES MUSEUM

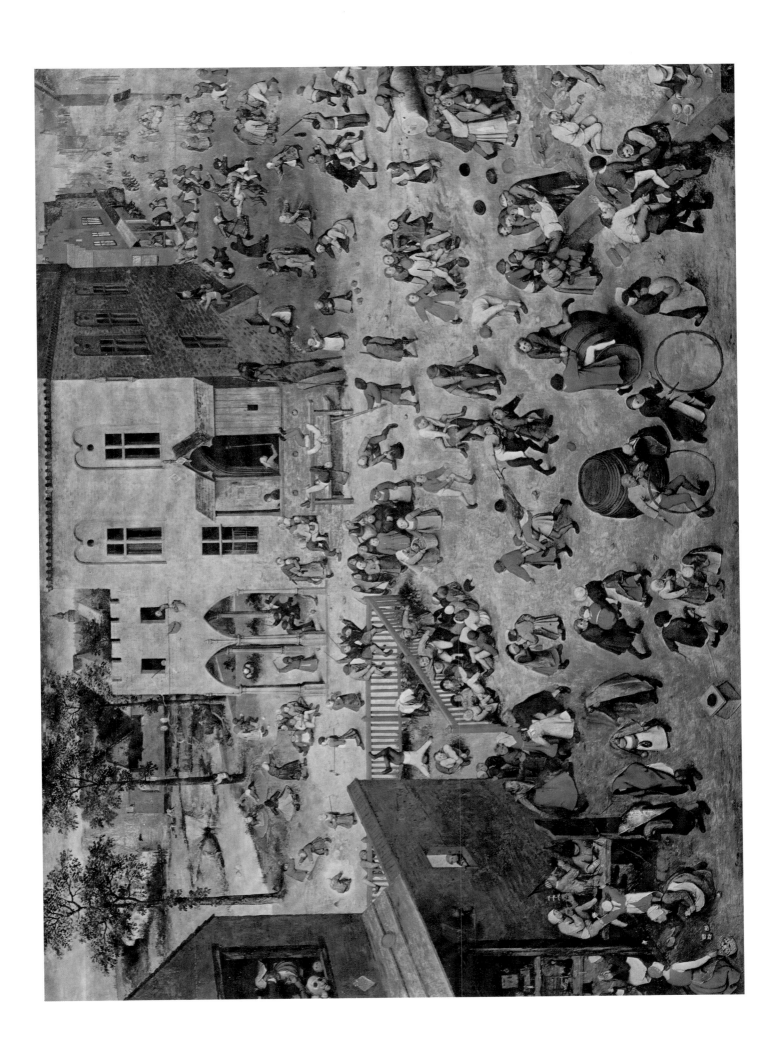

# Detail from 'Children's Games'

SEE PLATE 5

The painter's intention here is more serious than simply to compile an illustrated encyclopedia of children's games, though some eighty particular games have been identified. He shows the children absorbed in their games with the seriousness displayed by adults in their apparently more important pursuits. Bruegel's moral is that in the mind of God children's games possess as much significance as the activities of their parents. This idea was a familiar one in contemporary literature: in an anonymous Flemish poem published in Antwerp in 1530 by Jan van Doesborch, mankind is compared to children who are entirely absorbed in their foolish games and concerns.

Fig. 21
Detail from 'Children's Games'

PANEL, 1560. VIENNA, KUNSTHISTORISCHES MUSEUM

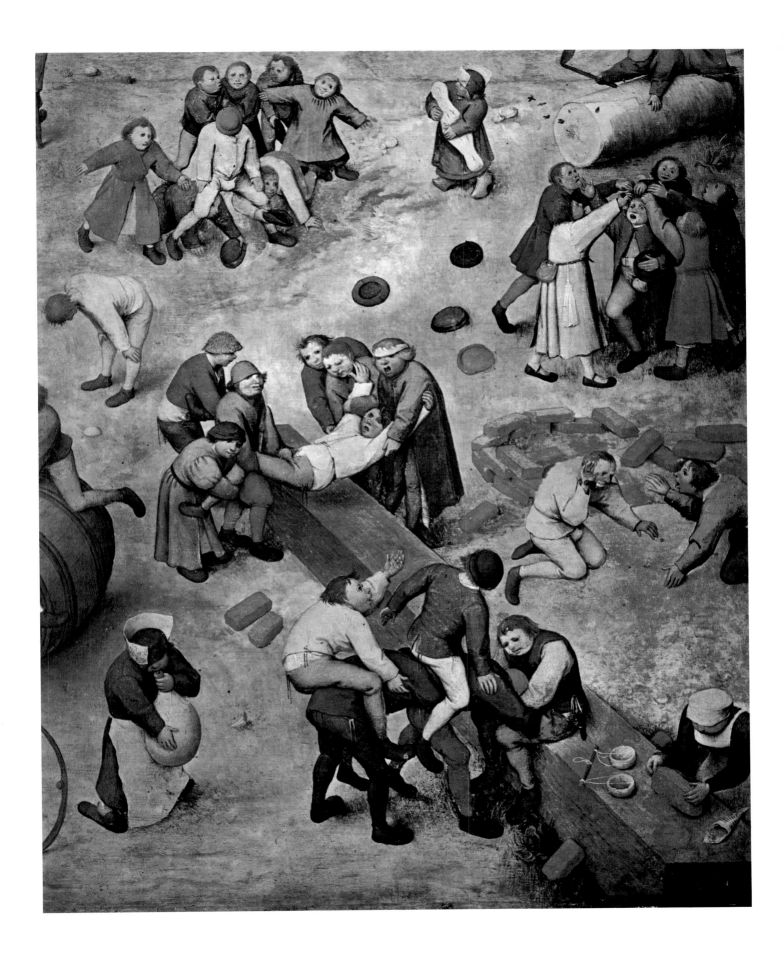

# Detail from 'The Fall of the Rebel Angels'

SEE FIG. 22

Painted in 1562, Bruegel's depiction of this subject again reveals his profound debt to Bosch, especially in the grotesque figures of the fallen angels, shown as half-human, half-animal monsters. The composition with a central figure placed among many smaller figures was favoured by Bruegel at this time not only in other paintings such as *Dulle Griet* (Plate 8) but also in the series of engravings of the Vices and Virtues which he had just completed for the Antwerp publisher Hieronymous Cock (Figs. 4, 36). The Archangel Michael and his angels are shown by Bruegel in the act of driving the rebel angels from Heaven. Pride was the sin which caused the fall of Lucifer and his companions, and the conflict of good and evil, vice and virtue, is a theme which recurs constantly in Bruegel's work.

Fig. 22
The Fall of the Rebel Angels

PANEL 117 × 162 CM (46 × 63¾ INS). 1562, BRUSSELS, MUSEES ROYAUX DES BEAUX-ARTS

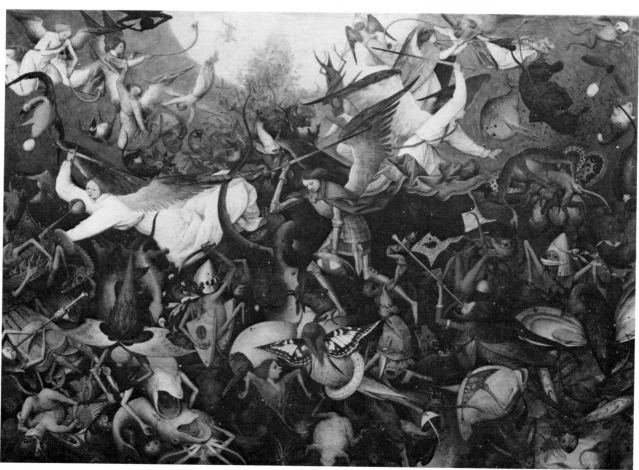

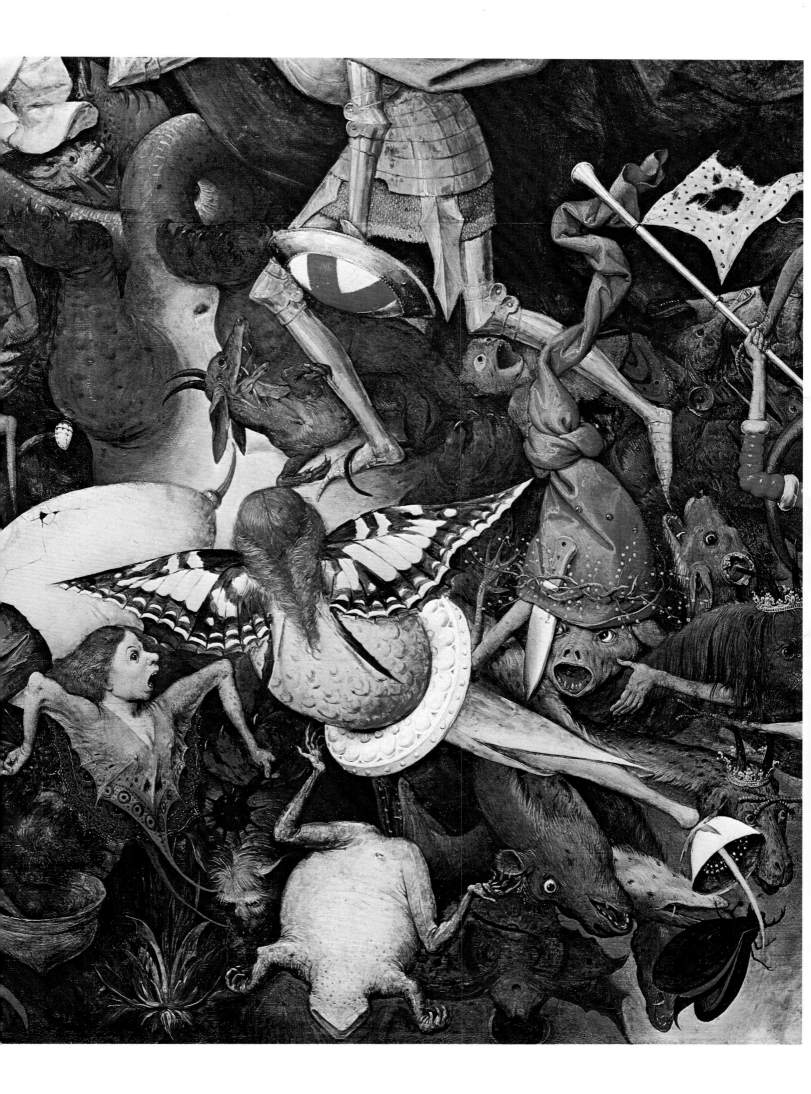

# 'Dulle Griet' (Mad Meg)

PANEL, 115 × 161 CM (45¼ × 63⅜ INS). C.1562. ANTWERP, MUSEUM MAYER VAN DEN BERGH

The signature and the date on the painting are illegible, but its close compositional and stylistic similarity to *The Fall of the Rebel Angels* (Plate 7) makes it likely that it was painted in about 1562. Like that picture, *Dulle Griet* owes much to Bosch.

Bruegel's earliest biographer, Carel van Mander, writing in 1604, described the painting as 'Dulle Griet, who is looking at the mouth of Hell'. Griet was a disparaging name given to any bad-tempered, shrewish woman. Her mission refers to the Flemish proverb: 'She could plunder in front of hell and return unscathed'. Bruegel is thus making fun of noisy, aggressive women. At the same time he castigates the sin of covetousness: although already burdened down with possessions, Griet and her grotesque companions are prepared to storm the mouth of Hell itself in their search for more.

Fig. 23
Detail from 'Dulle Griet' (Mad Meg)

PANEL, 1562. ANTWERP, MUSEUM MAYER VAN DEN BERGH

# 'Dulle Griet'

SEE PLATE 8

While her female followers loot a house, Griet advances towards the mouth of Hell through a landscape populated by Boschian monsters (Fig. 24). They represent the sins that are punished there. Griet wears male armour — a breastplate, a mailed glove and a metal cap; her military costume is parodied by the monster in a helmet beside her, who pulls up a drawbridge. A knife hangs from her side, while in her right hand she carries a sword, which may refer to the saying: 'He could go to Hell with a sword in his hand'. A book of proverbs published in Antwerp in 1568 contains a saying which is very close in spirit to Bruegel's painting: 'One woman makes a din, two women a lot of trouble, three an annual market, four a quarrel, five an army, and against six the Devil himself has no weapon.'

Fig. 24
Detail from 'Dulle Griet' (Mad Meg)

PANEL, 1562. ANTWERP, MUSEUM MAYER VAN DEN BERGH

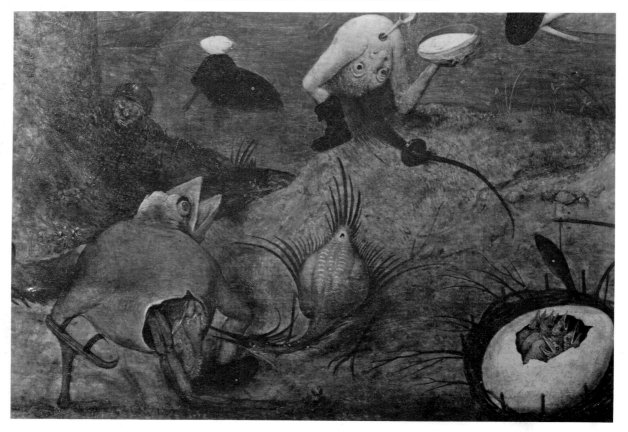

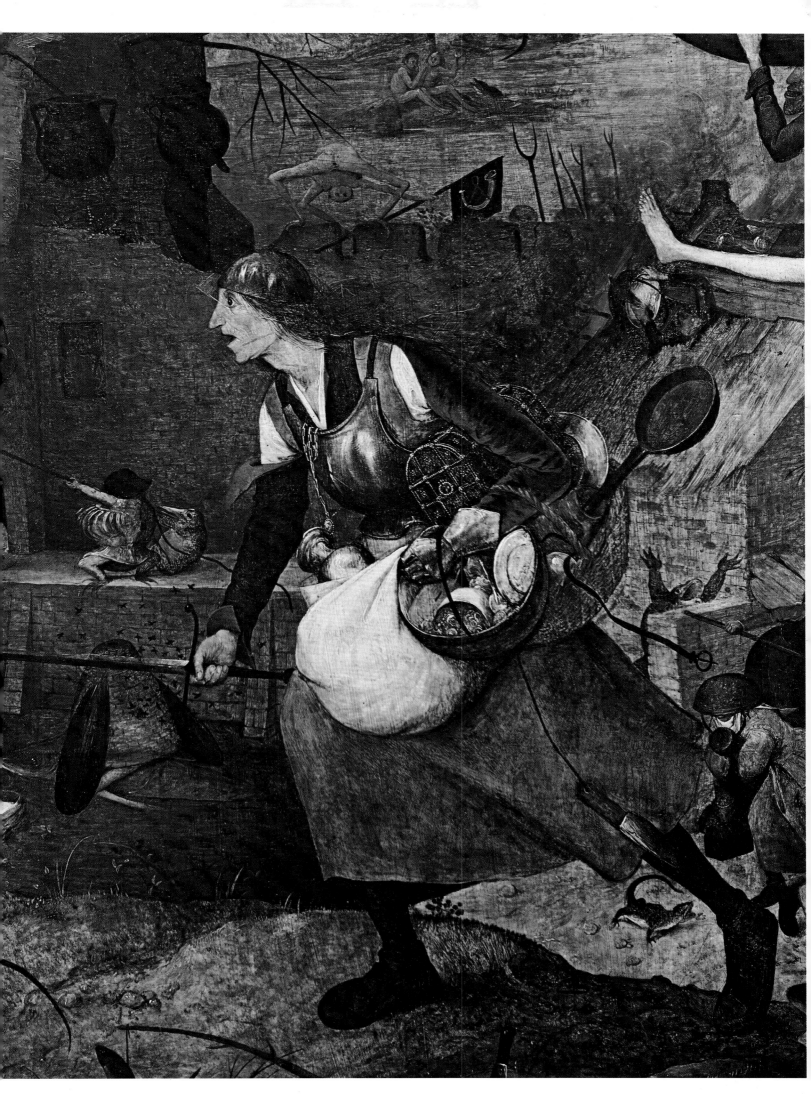

# The Triumph of Death

PANEL, 117 × 162 CM (46 × 63¼ INS). C.1562. VIENNA, KUNSTHISTORISCHES MUSEUM

Although it is neither signed nor dated, the subject-matter of this painting and its Bosch-derived imagery place it close in date to *The Fall of the Rebel Angels* (Plate 7) of 1562 and the *Dulle Griet* (Plate 8) of about the same time. This is apparently the painting mentioned by Carel van Mander in his life of Bruegel, 'in which expedients of every kind are tried out against death'. Bruegel combines two distinct visual traditions within this incident-crammed panel. These are his native tradition of Northern woodcuts of the Dance of Death and the Italian conception of the Triumph of Death, as in the frescoes he would have seen in the Palazzo Sclafani in Palermo and in the Camposanto at Pisa (Fig. 25). However, Bruegel's unforgettable version of the army of Death relentlessly advancing across a hellish landscape is quite original and is one of the most remarkable products of his imagination.

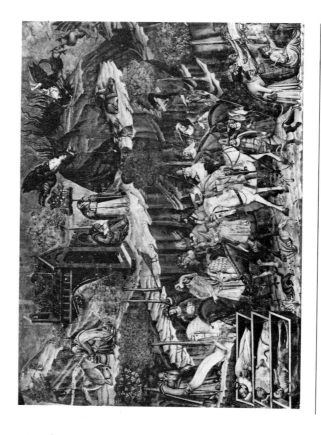

Fig. 25
FRANCESCO TRAINI (?)
Detail from 'The Triumph of Death'

FRESCO. PISA, CAMPOSANTO

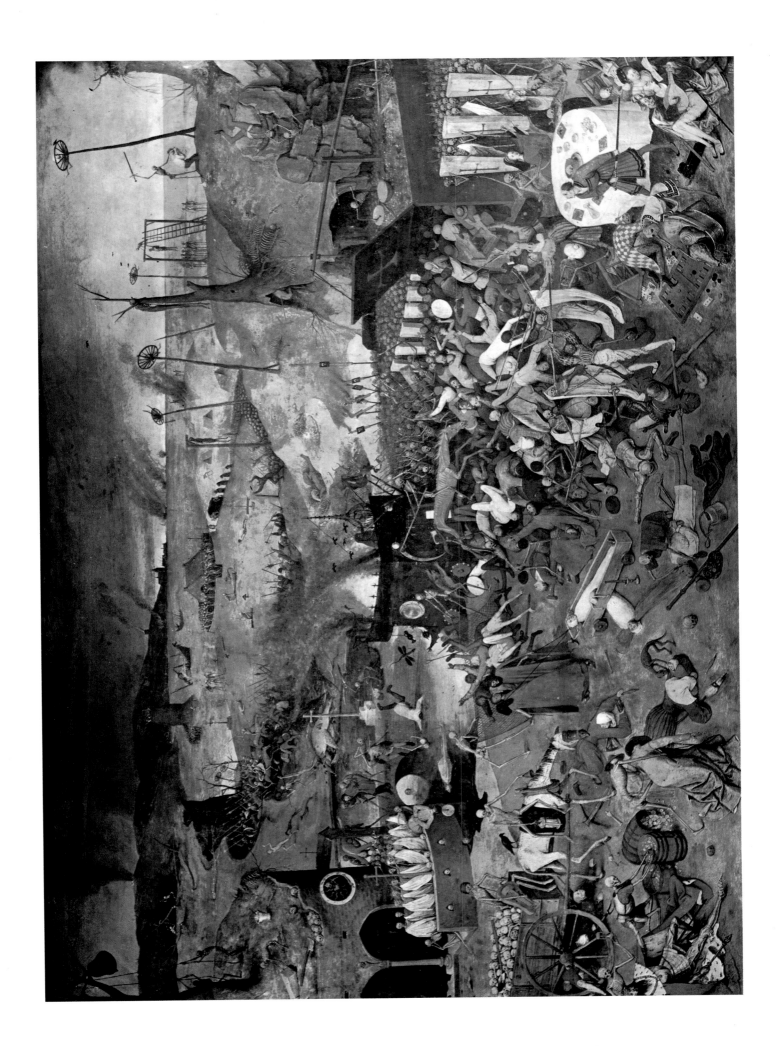

# Detail from 'The Triumph of Death'

SEE PLATE 10

For all men and women, however exalted their status on earth, there is no escape from the army of Death, which advances inexorably across Bruegel's burning landscape. This detail is crammed with a multitude of striking and horrifying individual images: the boat of death carrying its grisly cargo of skeletons draped in their winding-sheets and with skulls at the port-holes; the wagon-load of skulls and bones pulled along by an emaciated horse ridden by a skeleton tolling a bell and carrying a lamp. A second skeleton parodies human happiness by playing a hurdy-gurdy while the wheels of his cart crush a man. A woman has fallen in the path of the death cart; she holds in her hand a spindle and distaff, classical symbols of the fragility of human life. The slender thread is about to be cut by the scissors in her other hand. Just below her a cardinal is helped towards his fate by a skeleton who mockingly wears the red hat, while a dying king's barrel of gold coins is looted by a skeleton.

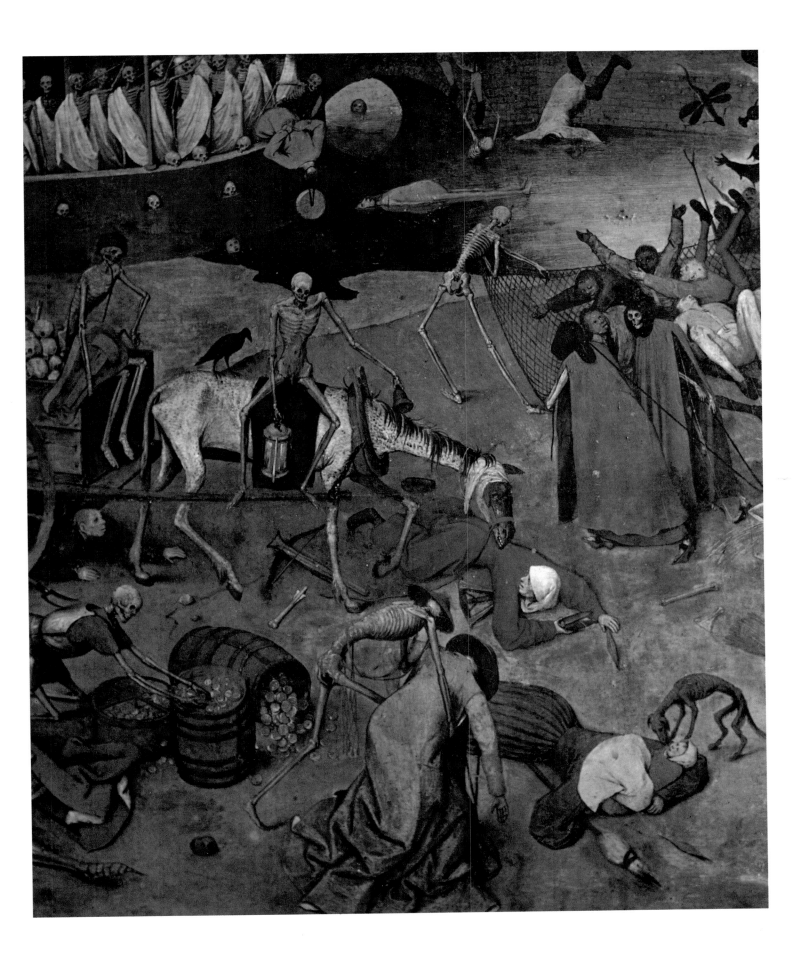

# Detail from 'The Triumph of Death'

SEE PLATE 10

In this detail from Bruegel's crowded and horrifying vision of the inevitability of death, a dinner has been broken up by the intrusion of the army of Death and the diners are putting up a futile resistance. They have drawn their swords in order to fight the skeletons dressed in winding-sheets; no less hopelessly, the jester takes refuge beneath the dinner table. The backgammon board and the playing cards have been scattered, while a skeleton thinly disguised with a mask empties away the wine flasks. Above, a woman is being embraced by a skeleton in a hideous parody of after-dinner amorousness.

Fig. 26
Detail from 'The Triumph of Death'

PANEL, C.1562. MADRID, PRADO

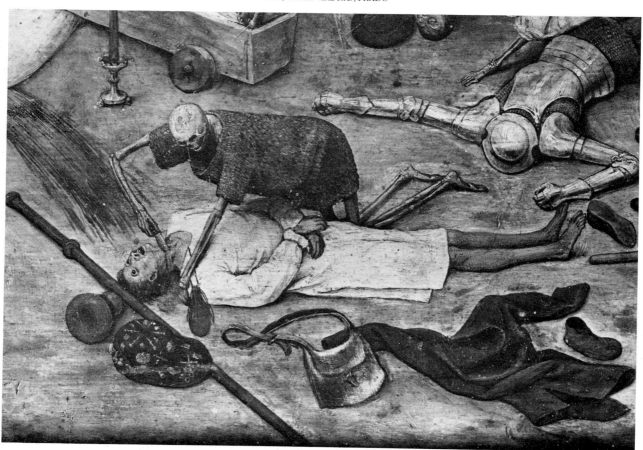

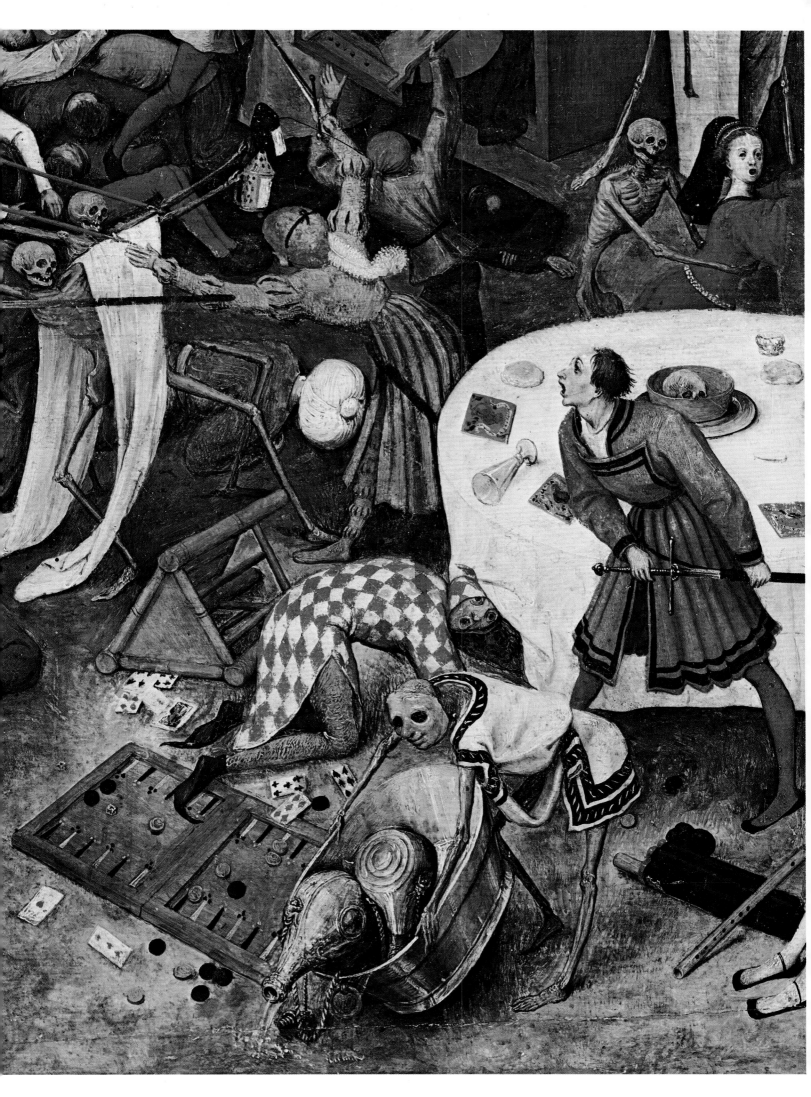

# The Suicide of Saul

PANEL, 33.5 × 55 CM (13¼ × 21⅝ INS). INSCRIBED AND SIGNED, 1562. VIENNA, KUNSTHISTORISCHES MUSEUM

The inscription identifies the subject as the rarely represented scene of the suicide of Saul after his defeat by the Philistines. These events are described in 1 Samuel 31, 1–5: 'Now the Philistines fought against Israel: and the men of Israel fled from before the Philistines and fell down slain in Mount Gilboa. And the Philistines followed hard upon Saul and his sons: and the Philistines slew Jonathan, and Abinadab and Malchishua, Saul's sons. And the battle went sore against Saul, and the archers hit him; and he was sore wounded of the archers. Then Saul said unto his armourbearer, Draw thy sword and thrust me through therewith: lest these uncircumcised come and thrust me through and abuse me. But his armourbearer would not; for he was sore afraid. Therefore Saul took a sword, and fell upon it. And when his armourbearer saw that Saul was dead he fell likewise upon his sword and died with him.' Bruegel has chosen the highly dramatic moment of the death of the armourbearer, just as the Philistines are approaching.

Saul's death was interpreted as a punishment of pride — it was among the proud that Dante met Saul in the *Purgatorio* — and this may account for Bruegel's choice of such an unusual subject.

# Detail from 'The Suicide of Saul'

SEE PLATE 13

As with most of his subjects taken from the Bible, Bruegel treats Saul's suicide as a contemporary event, showing the armies in sixteenth-century armour. In 1529 the German painter Albrecht Altdorfer had shown the clash of the forces of Alexander the Great and Darius at the Battle of the Issus in this way, and in many other respects, too, Bruegel is in Altdorfer's debt, particularly in the representation of the tiny, massed figures of the soldiers and their forests of lances. Bruegel may also have looked at the battle-scenes of another German painter, Jörg Breu the Younger, and at a now lost battle-scene by the Antwerp landscape painter Joachim Patinir which is mentioned by van Mander.

*The Suicide of Saul* is an early attempt by Bruegel to reconcile landscape and figure painting. If it is compared with one of his latest works, *The Magpie on the Gallows* of 1568 (Plate 49), its weaknesses are apparent: the foreground and background are not yet reconciled and the jutting outcrop of rock in the centre is a mannerist device which we see again in *The Procession to Calvary* (Plate 17). However, the distant landscape is seen through a shimmering haze, which seems to have the effect of emphasizing the foreground detail, and this does represent a new stage in the evolution of Bruegel's depiction of naturalistic landscape.

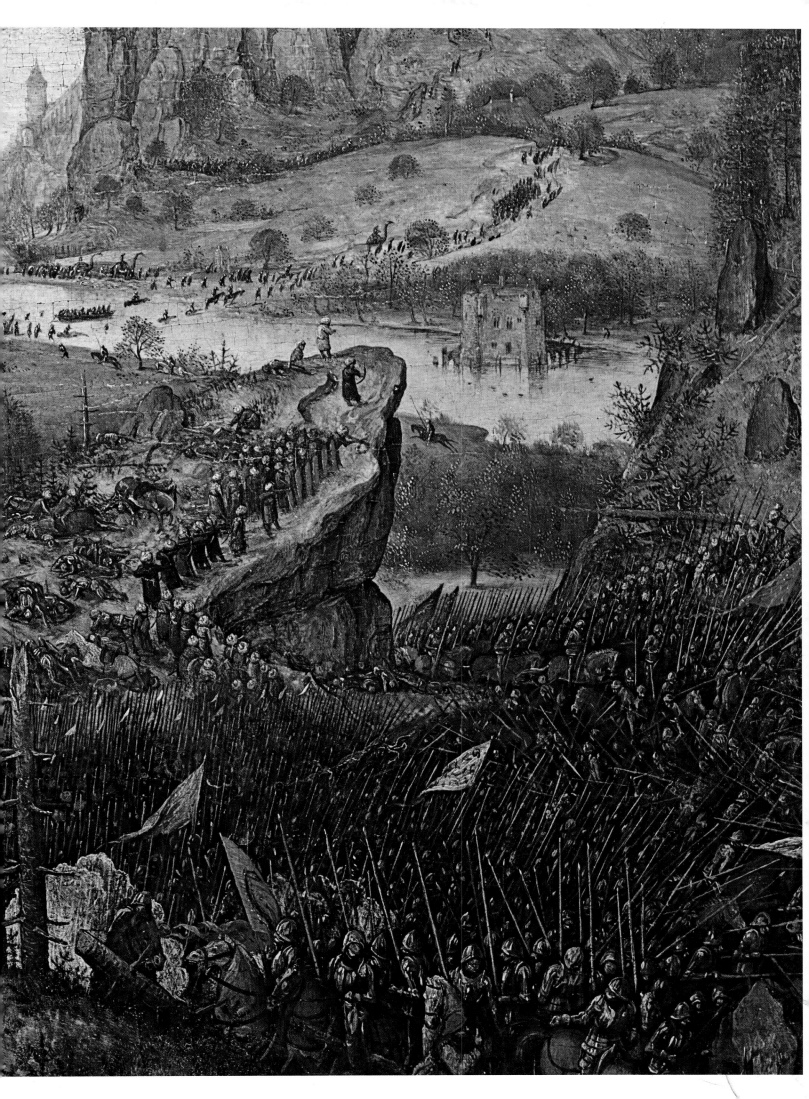

# The Tower of Babel

PANEL, 114 × 155 CM (44⅞ × 61 INS). SIGNED AND DATED, 1563. VIENNA KUNSTHISTORISCHES MUSEUM

The story of the Tower of Babel (like that of the Suicide of Saul) was interpreted as an example of pride punished, and that is no doubt what Bruegel intended his painting to illustrate. He painted the subject of the Tower of Babel three times. The first version, very small and painted on ivory, is mentioned in the inventory of Giulio Clovio, the famous miniaturist, whom Bruegel met and collaborated with in Rome in 1553. Sadly it is now lost. The second version was this painting on panel, which is dated 1563, and the third was a smaller painting, now in the Museum Boymans-van Beuningen in Rotterdam (Fig. 27). The Rotterdam painting is generally thought to date from a year or so after the picture in Vienna. The latter is more traditional in its treatment of the subject in that it includes the visit of King Nimrod to the incomplete Tower, in the lower right-hand corner.

Bruegel's Tower has marked similarities to the Colosseum and other Roman monuments, which the artist would have seen during his stay in Italy ten years earlier. Back in Antwerp, he must have refreshed his memory of Rome with a series of engravings of the principal landmarks of the city made by the publisher of his own prints, Hieronymous Cock, for he incorporated details of Cock's Roman engravings in both surviving versions of the Tower of Babel with few significant alterations. The parallel of Rome and Babylon had a particular significance for Bruegel's contemporaries. Rome was the Eternal City, intended by the Caesars to last for ever, and its decay and ruin were taken to symbolize the vanity and transience of earthly efforts.

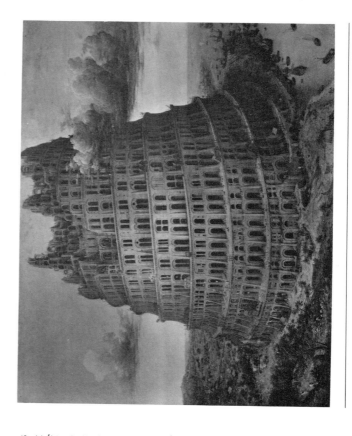

Fig. 27
The Tower of Babel

PANEL, 60 × 74.5 CM (23⅝ × 29⅜ INS). ROTTERDAM, MUSEUM BOYMANS – VAN BEUNINGEN

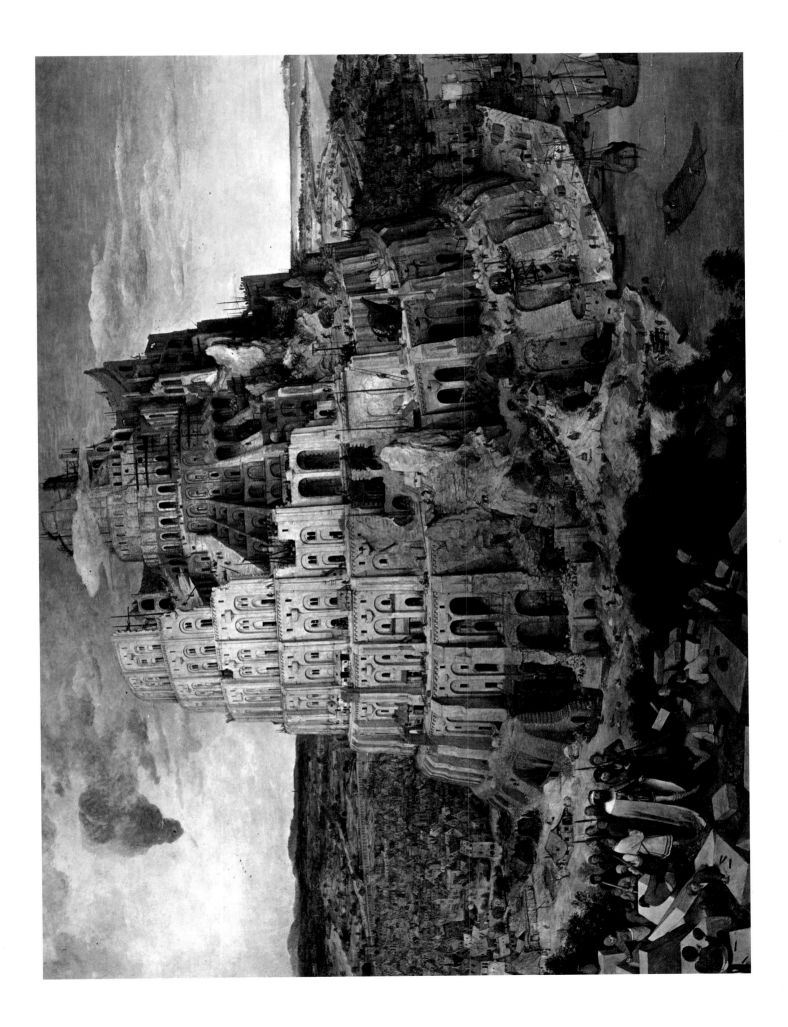

# Detail from 'The Tower of Babel'

SEE PLATE 15

The hectic activity of the engineers, masons and workmen points to a second moral — the futility of much human endeavour. Nimrod's doomed building was used to illustrate this meaning in Sebastian Brant's *Ship of Fools*. Bruegel's knowledge of building procedures and techniques is considerable and correct in detail. The skill with which he has shown these activities recalls that his very last commission, left unfinished at his death, was for a series of documentary paintings recording the digging of a canal linking Brussels and Antwerp.

Fig. 28
Detail from 'The Tower of Babel'

PANEL, 1563. VIENNA, KUNSTHISTORISCHES MUSEUM

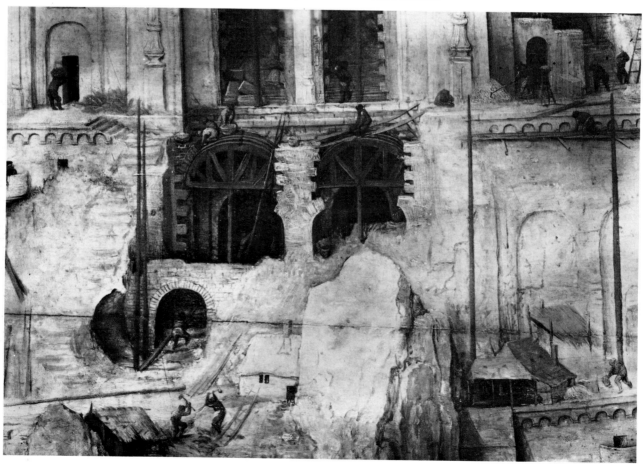

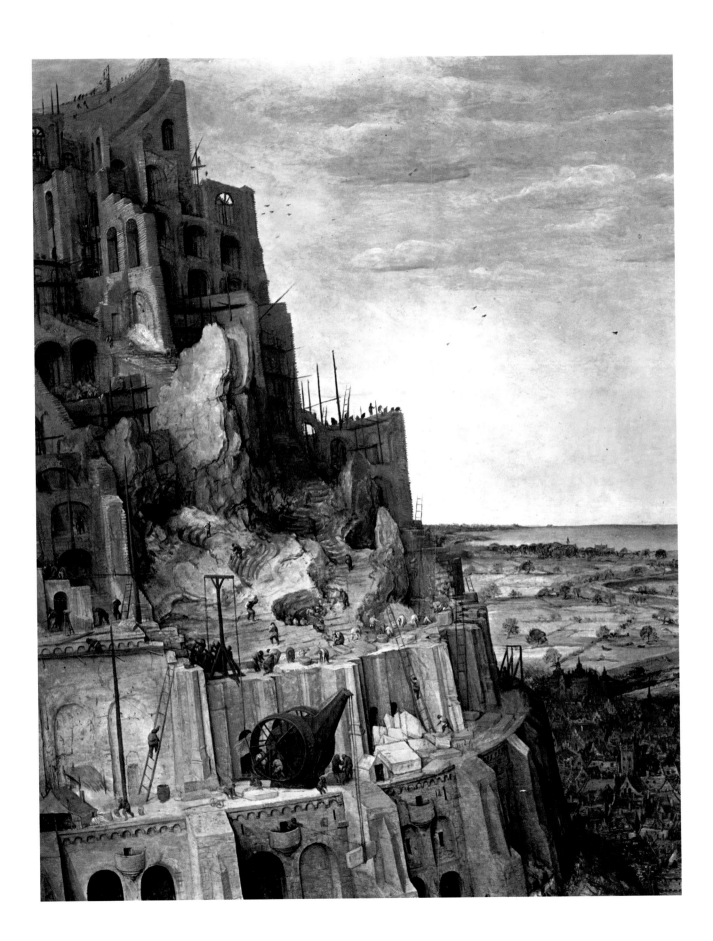

# The Procession to Calvary

PANEL, 124 × 170 CM (48¾ × 66⅞ INS). SIGNED AND DATED, 1564. VIENNA, KUNSTHISTORISCHES MUSEUM

This is the largest known painting by Bruegel. It is one of sixteen paintings by him which are listed in the inventory of the wealthy Antwerp collector, Niclaes Jonghelinck, drawn up in 1566. It was Jonghelinck who commissioned the *Months* (Plates 23, 26, 30, 33 and 34) from Bruegel and he may also have commissioned this painting. Jonghelinck's Bruegels passed into the possession of the city of Antwerp in the year in which the inventory was made. Many were subsequently owned by Archduke Ernst, Regent of the Netherlands, and afterwards entered the Imperial collection.

For Bruegel the composition is unusually traditional. Perhaps because he was treating such a solemn religious event, he adopted a well-known scheme, used previously by the Brunswick Monogrammist (who has been identified as Jan van Amstel) and Bruegel's Antwerp contemporary, Pieter Aertsen. Christ's insignificance among the crowds is a familiar device of mannerist painting (it recurs in *The Sermon of St John the Baptist*, Fig. 29), as is the artificial placing of Mary and her companions in a rocky foreground, which is deliberately distanced from the dramatic events taking place behind them.

Fig. 29
The Sermon of St John the Baptist

PANEL, 95 × 160.5 CM (37⅜ × 63¼ INS). 1566. BUDAPEST, MUSEUM OF FINE ARTS

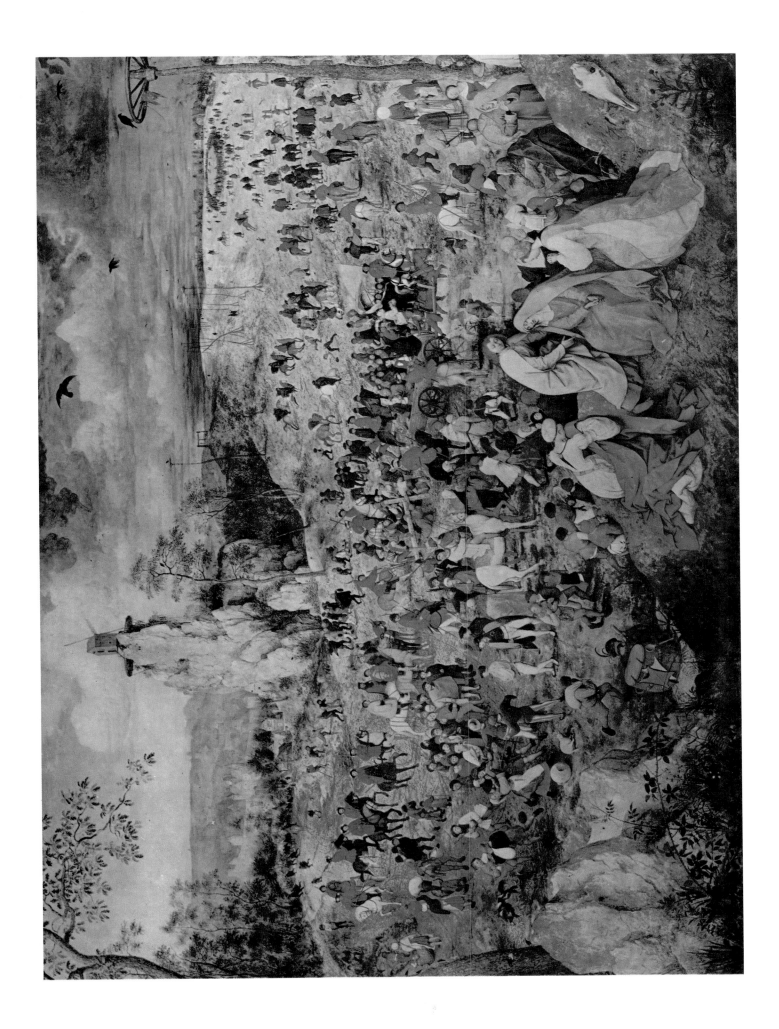

# Detail from 'The Procession to Calvary'

SEE PLATE 17

Bruegel's treatment of landscape evolves in the course of his career from the bird's-eye views and extensive landscapes of the *Large Landscape* series (Figs. 2 and 3) to the remarkable naturalism of the *Months* (Plates 23, 26, 30, 33 and 34). Impossibly sheer outcrops of rock like this one characterize the landscape tradition of the Antwerp school founded by Joachim Patinir. Patinir's followers — in particular Herri met de Bles, Matthys Cock (the brother of Bruegel's print publisher, Hieronymous) and Cornelis Massys — had turned his style into a popular but stale formula. The sequence of Bruegel's landscape drawings and of the landscape in his paintings shows the gradual abandonment of this formula. In this case, however, his desire to convey the rocky, unfamiliar terrain of the Holy Land causes him to fall back on the ready-made landscape features of the Antwerp school.

# Detail from 'The Procession to Calvary'

SEE PLATE 17

In a detail such as this, Bruegel's painting possesses a vividness which would seem to come directly from his observation of contemporary life. Public executions were a familiar feature of sixteenth-century life, especially in troubled Flanders. Here Bruegel shows the two thieves who were to hang on either side of Christ being trundled to the place of execution. Both clutch crucifixes and are making their final confessions to the cowled priests beside them. The thieves, their confessors and the ghoulish spectators who surround the cart are all in contemporary dress. In Bruegel's day public executions were well attended occasions which had the air of festivals or carnivals. Here Bruegel shows the absolute indifference of the gawping crowds to the fear and misery of the condemned men. (Elsewhere in the picture he shows the pickpockets and the pedlars who preyed upon the crowds at such events.) It is noteworthy that Bruegel makes no distinction between the two thieves, one of whom Christ was to bless.

On the mount of Golgotha (literally, 'place of skulls') the two crosses which are to bear the bodies of the thieves have been erected and a hole is being dug for the cross which is to bear Christ's body (Fig. 30). Onlookers on foot and on horseback flock towards this gruesome spot through a landscape dotted with gallows on which corpses still hang and wheels to which fragments of cloth and remnants of broken bodies not eaten by the ravens still cling.

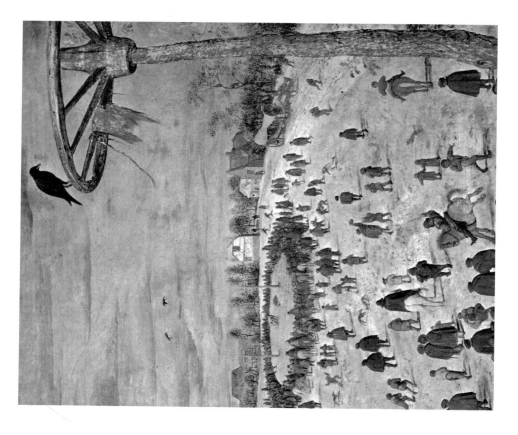

Fig. 30 (right)
Detail from 'The Procession to Calvary'

PANEL, 1564. VIENNA, KUNSTHISTORISCHES MUSEUM

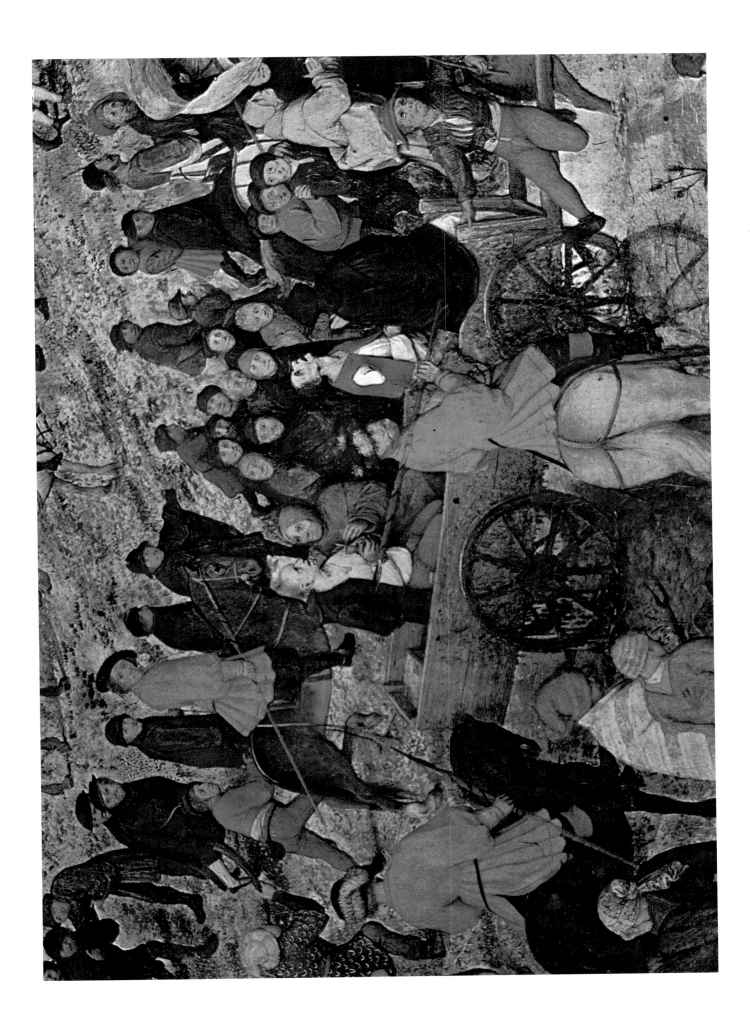

# Detail from 'The Procession to Calvary'

SEE PLATE 17

With the exception of Christ himself, the figures in the procession wear contemporary dress, and there can be no doubt that Bruegel meant his representation of the scene to have a particular reference to his own day. The sacred figures — the fainting Virgin assisted by St John and the other two Maries (only one of whom is shown here, on the right) — are separated from the main events by being placed on a small, rocky plateau. They act out their own, apparently independent, drama, largely unnoticed by the figures behind them. Larger than the background figures and isolated from them, the Virgin and her companions occupy a separate, timeless world, clearly removed from the contemporary world and yet having the most profound significance for it.

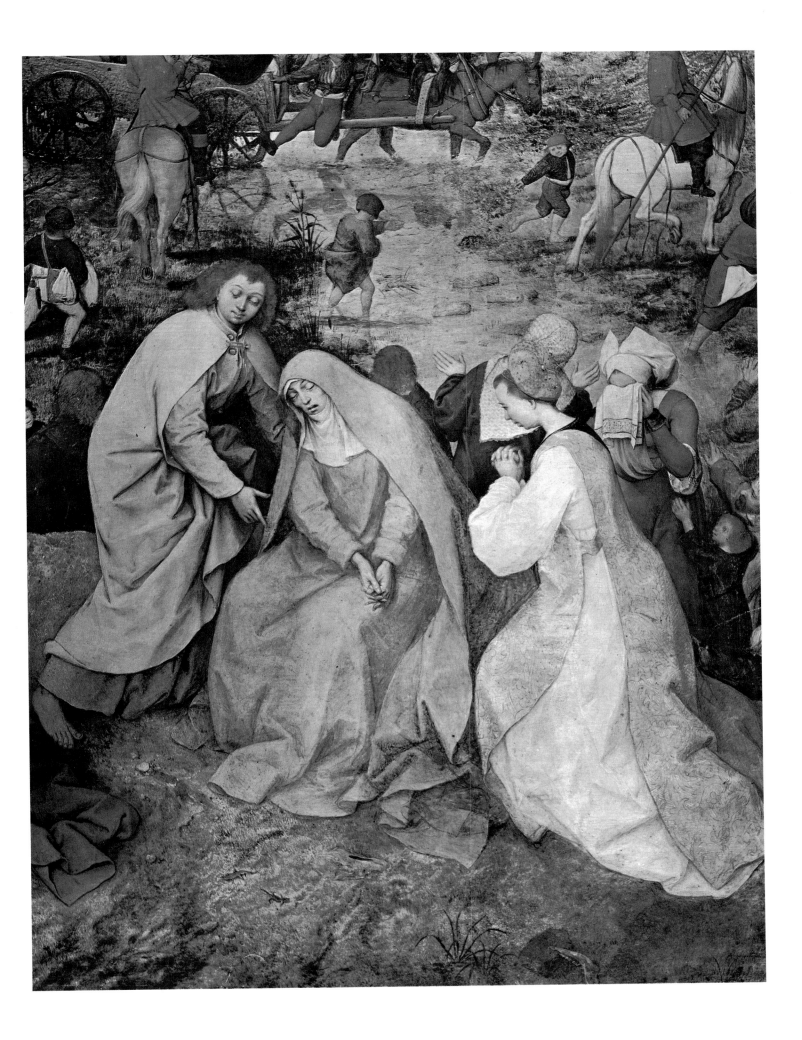

# The Adoration of the Kings

PANEL, 111 × 83.5 CM (43¾ × 32¾ INS). SIGNED AND DATED, 1564. LONDON, NATIONAL GALLERY

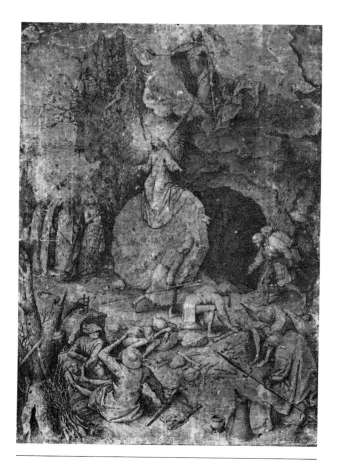

In the chronological sequence of Bruegel's work, this painting of 1564 marks an important departure as the first to be composed almost exclusively of large figures. The group of figures, taken from Italian mannerist painters like Parmigianino, permits Bruegel to concentrate on individual faces, giving each a quite distinct, and sometimes grotesque, expression. This emphasis on the uniqueness of each figure, and Bruegel's lack of interest in depicting ideal beauty in the Italian manner, makes it clear that although borrowing an Italian compositional scheme, Bruegel is putting it to quite a different use. In this treatment, the painter's first purpose is to record the range and intensity of individual reactions to the sacred event.

This *Adoration* and a *Resurrection* in grisaille (Fig. 31) are the only upright paintings by Bruegel.

Fig. 31
The Resurrection of Christ

BRUSH AND PEN DRAWING IN GRISAILLE ON PAPER ATTACHED TO A
PANEL, 43.1 × 30.7 CM (17 × 12¼ INS). C.1562. ROTTERDAM, MUSEUM
BOYMANS — VAN BEUNINGEN

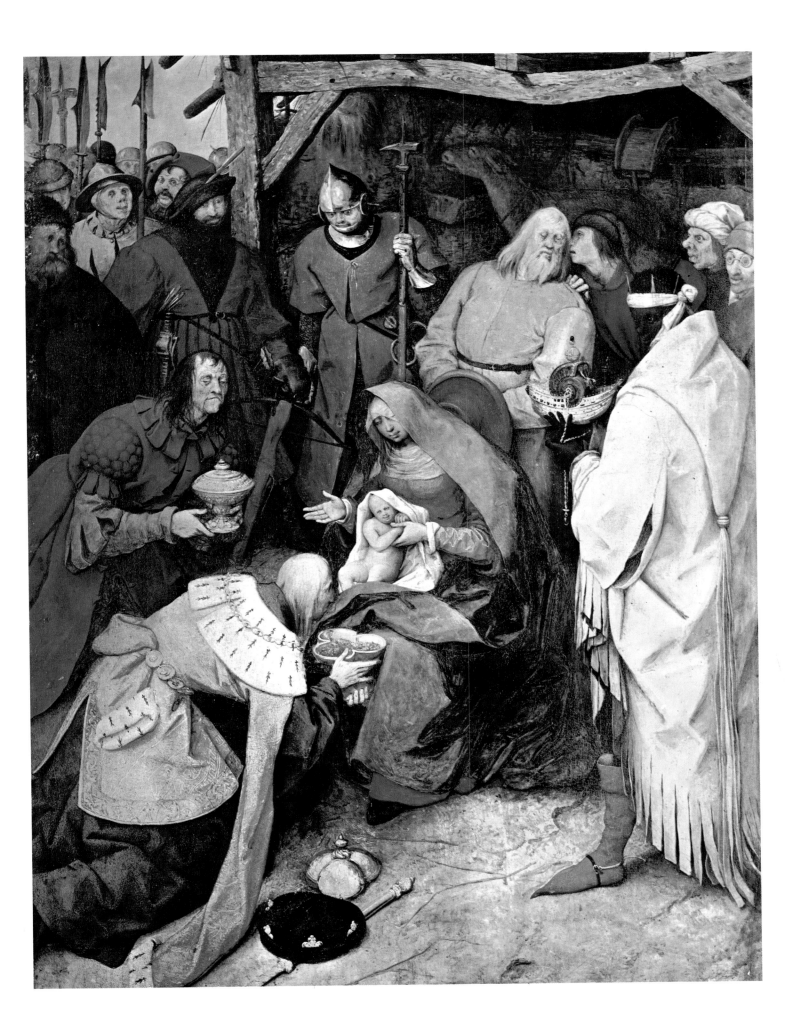

# The Death of the Virgin

PANEL, 36 × 54.5 CM (14¼ × 22 INS). SIGNED. C.1564. UPTON HOUSE, BANBURY, OXFORDSHIRE (NATIONAL TRUST)

This grisaille panel was painted about 1564 (the traces of the date alongside the signature are illegible) for Abraham Ortelius, the great Antwerp geographer, who was a close friend of Bruegel. Ortelius commissioned Philip Galle to engrave the composition in 1574 for presentation to his friends. One of the recipients of the engraving was the Haarlem theologian D.V. Coornhert, whose non-sectarian religious thought had influenced Bruegel himself. Coornhert wrote to Ortelius thanking him for the gift, and his letter provides a fascinating contemporary account of Bruegel's art:

'Your valued gift, good Ortelius, came to me as I was pondering how to express my gratitude in return. I examined it with pleasure for the artistry of its drawing and the care of its engraving. Bruegel and Philip have surpassed themselves. Neither of them, in my opinion, could have done better. Their friend Abraham Ortelius' favour has spurred on their natural talents, so that this work of art in its skill shall survive for art-lovers for all time. Never, in my opinion, did I see more able drawing or finer engraving than this sorrowful chamber. What do I say? I actually heard (so it seemed) the melancholy words, the sobbing, the weeping and the sounds of woe. I believe I heard moaning, groaning and screaming and the splashing of tears in this portrayal of sorrow. There no one can restrain himself from sadly wringing his hands, from grieving and mourning, from lamenting and from the tale of woe. The chamber appears deathlike, yet all seems to me alive.'

Bruegel's interpretation of the scene is unusual in the exceptionally large numbers of the just who crowd around the Virgin's deathbed. The literary source for this is Jacobus de Voragine's *Golden Legend*, which tells of numerous holy persons being present when Mary was reunited with her son.

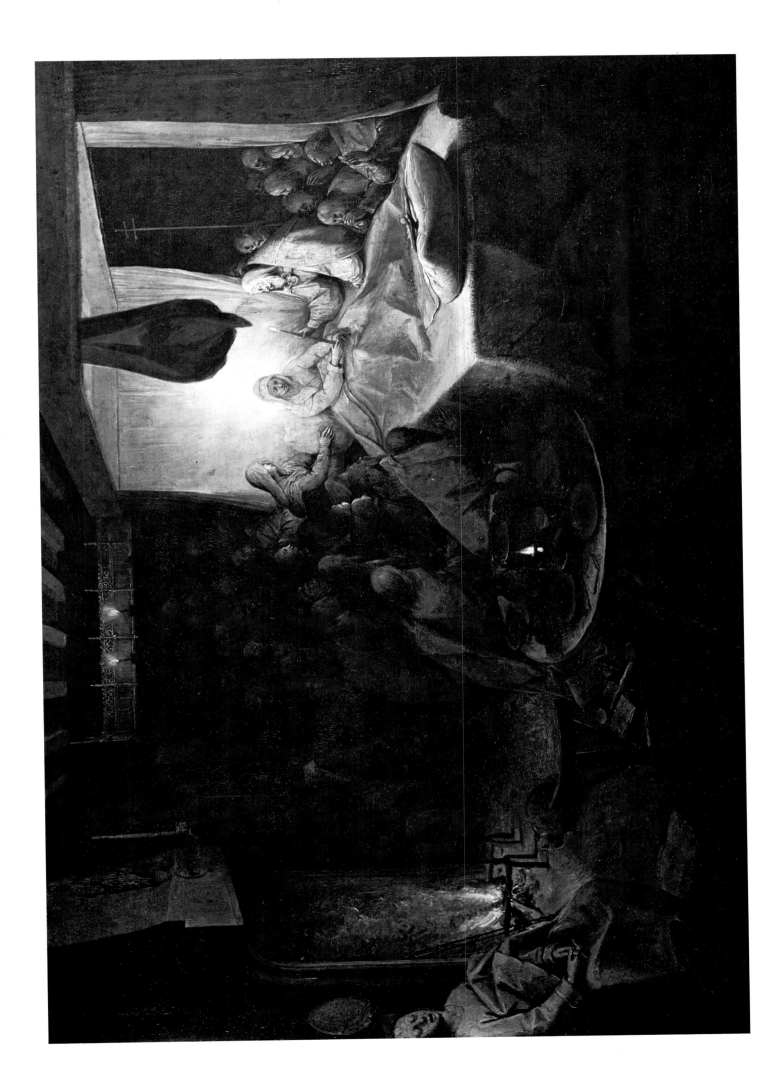

# The Hunters in the Snow (January)

PANEL, 117 × 162 CM (46 × 63¾ INS). SIGNED AND DATED, 1565. VIENNA, KUNSTHISTORISCHES MUSEUM

This is the first of a series of paintings of the Months, of which only five remain: the others are *The Gloomy Day* (February; Plate 30), *Haymaking* (July; Plate 26), *The Corn Harvest* (August; Plate 33) and *The Return of the Herd* (November; Plate 34). The series was commissioned by Niclaes Jonghelinck, a wealthy Antwerp merchant who at the time of his death owned sixteen paintings by Bruegel. Jonghelinck's brother, the sculptor Jacques, was a friend of the painter. The paintings of the Months were completed by February 1566; they were intended as part of a large-scale decorative scheme for the interior of the merchant's palatial house in Antwerp. Frans Floris, an Italianate history painter who was the most successful Antwerp artist of the day, took a leading part in the scheme. As was usual in Flemish interiors of the time, Bruegel's landscape series was probably hung high up on the walls above the panelling, forming a continuous frieze around the room.

The whole decorative scheme of the Months appears to have been completed in a single year. A study of Bruegel's bold but absolutely sure technique confirms his swift method of working. He painted thinly, often using the gesso preparation of the panel as a distinct element in the composition. His treatment of figures, trees and distant buildings shows them reduced to swift notations with every line and every patch of colour in its proper place.

It was not just on the series of the Months that Bruegel worked quickly. All his forty-eight surviving paintings, with the exception of three early works, were produced in no more than twelve years (1557-68) and two-thirds of this output — thirty supreme masterpieces — were painted during his last six years in Brussels. It was his absolute technical assurance which made such a work-rate possible.

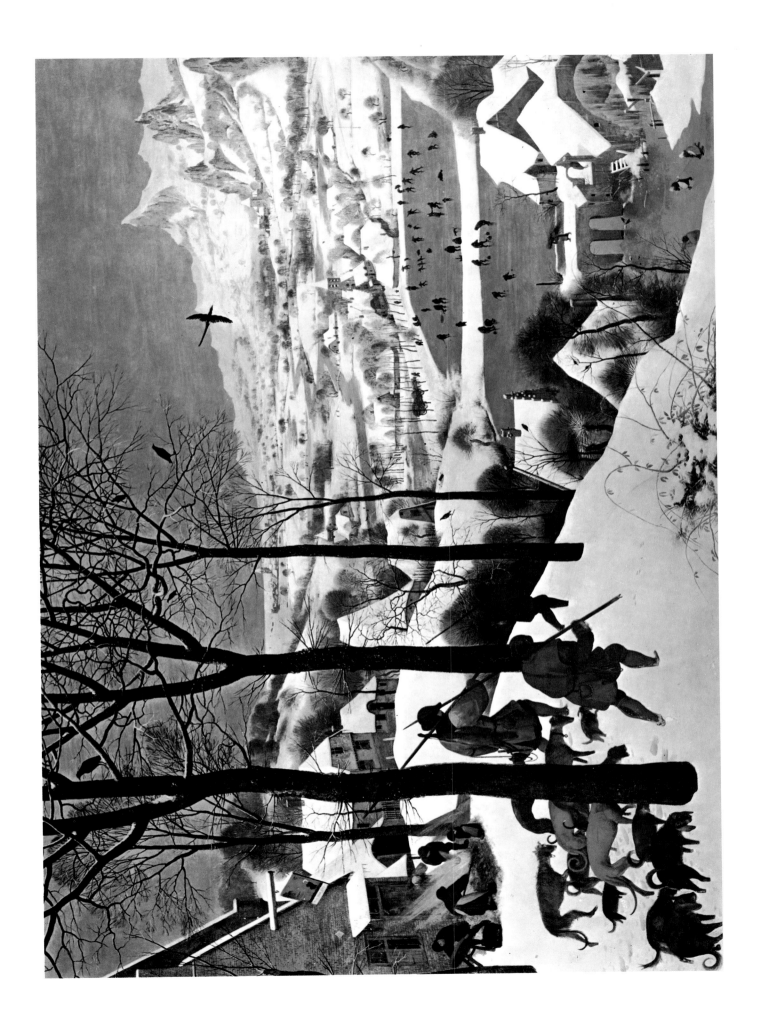

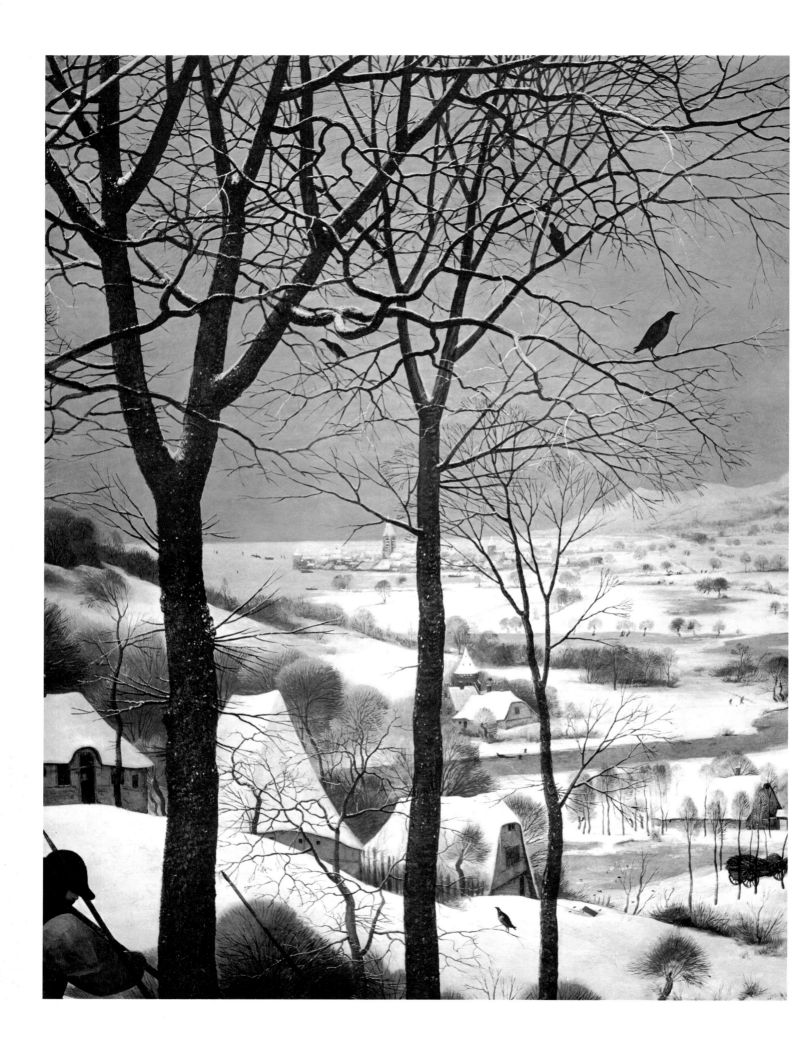

Details from
'The Hunters
in the Snow
(January)'

SEE PLATE 23

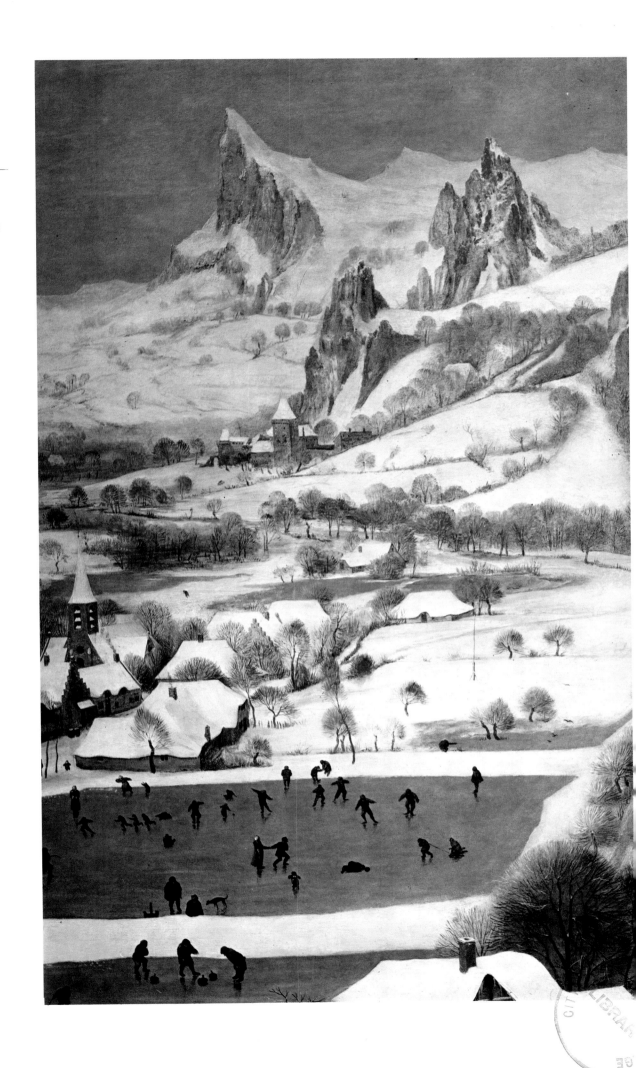

# The Gloomy Day (February)

PANEL, 118 × 163 CM (46½ × 64⅛ INS). SIGNED AND DATED, 1565. VIENNA, KUNSTHISTORISCHES MUSEUM

This is the second panel in the series of the *Months* painted by Bruegel for Niclaes Jonghelinck. There has been much discussion as to whether the series was made up of twelve panels, as was usual, or of six, each of which would have represented the activities of two months. There is, however, little reason to doubt that Bruegel used the tra-ditional scheme of twelve paintings. All five that survive belong to a well-established northern tradition of the representation of the months, which goes back to the calendar illustrations in medieval manuscript illuminations. February is shown as a dark, stormy month during which the peasants gather wood for their fires.

# Detail from 'The Gloomy Day' (February)

SEE PLATE 26

February is Carnival month and the child in this detail wears a festive paper crown and carries a lamp, while the man is shown eating waffles, the traditional carnival delicacy. Similarly dressed figures can be seen on Carnival's side of the square in *The Fight between Carnival and Lent* (Plate 2).

# Detail from 'The Gloomy Day' (February)

SEE PLATE 26

In February the thatchers repair the ravages of the winter storms and the farmers cover their waggon-loads of grain to protect them from the rain. As it is also carnival month, the villagers dance to the accompaniment of the village fiddler.

# Detail from 'The Gloomy Day' (February)

SEE PLATE 26

This detail shows the economy and spontaneity of Bruegel's technique. On the light brown gesso ground of the panel he has sketched in the castle, the mountain tops and the clouds with a few deft strokes of white and blue pigments, using a lightly loaded, almost dry, brush. While we admire such freedom of brushwork, it was not of course Bruegel's intention that the paintings should be examined in details such as this. The *Months* were to be seen from a distance, high up above the panelling of a large room.

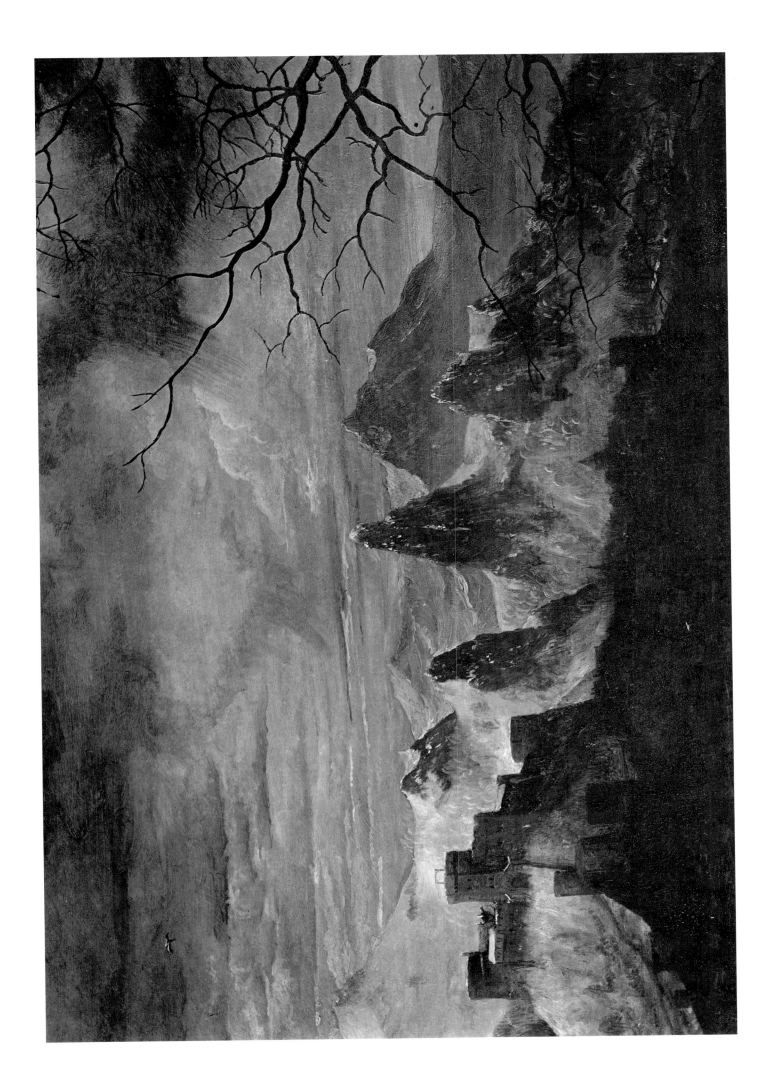

# Haymaking (July)

PANEL, 117 × 161 CM (46 × 63¾ INS). 1565. PRAGUE, NATIONAL GALLERY

Neither the signature nor the date have survived on this panel, but it clearly belongs to the series of the *Months*, all the other panels of which are dated 1565. July and August are the months of the harvest, and this painting and the August panel (Plate 33) show the bringing-in of the harvest. It is not just the grain that is being harvested but, as can be seen in the foreground, vegetables and berries as well. While each painting in the series shows the traditional occupation of that month, Bruegel's real subject is the landscape itself, its ever-changing appearance. There is a profound sense in which human activity is at best peripheral to the life of the landscape itself. Bruegel is concerned to show that the seasonal concerns of men are dictated by the land.

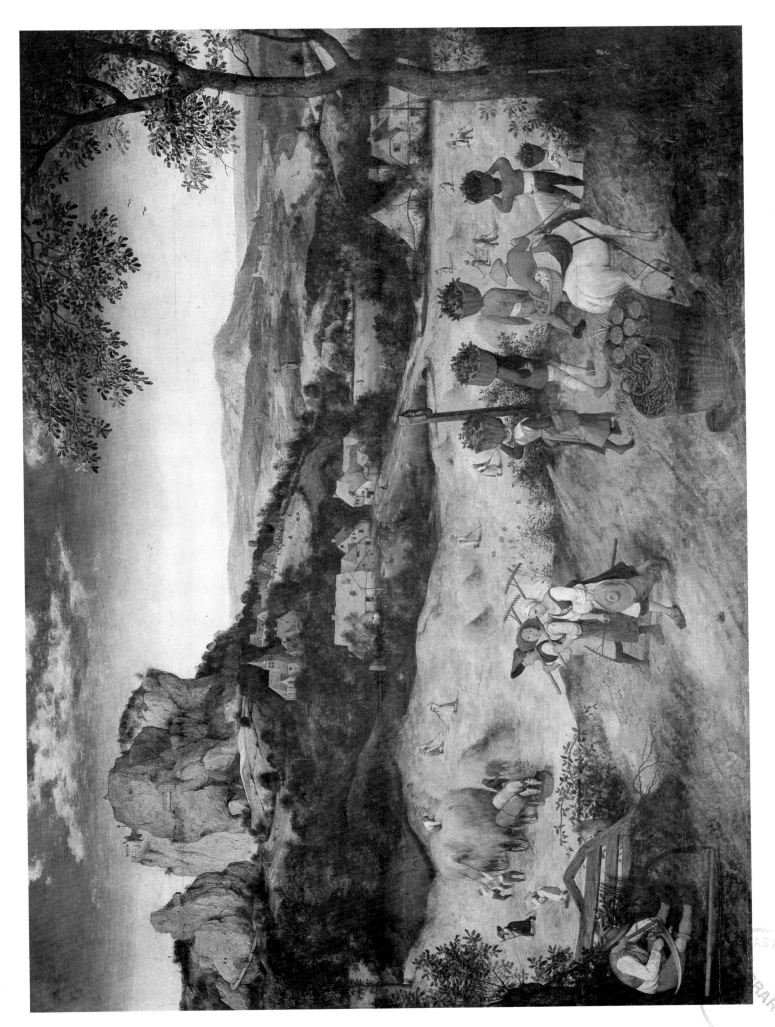

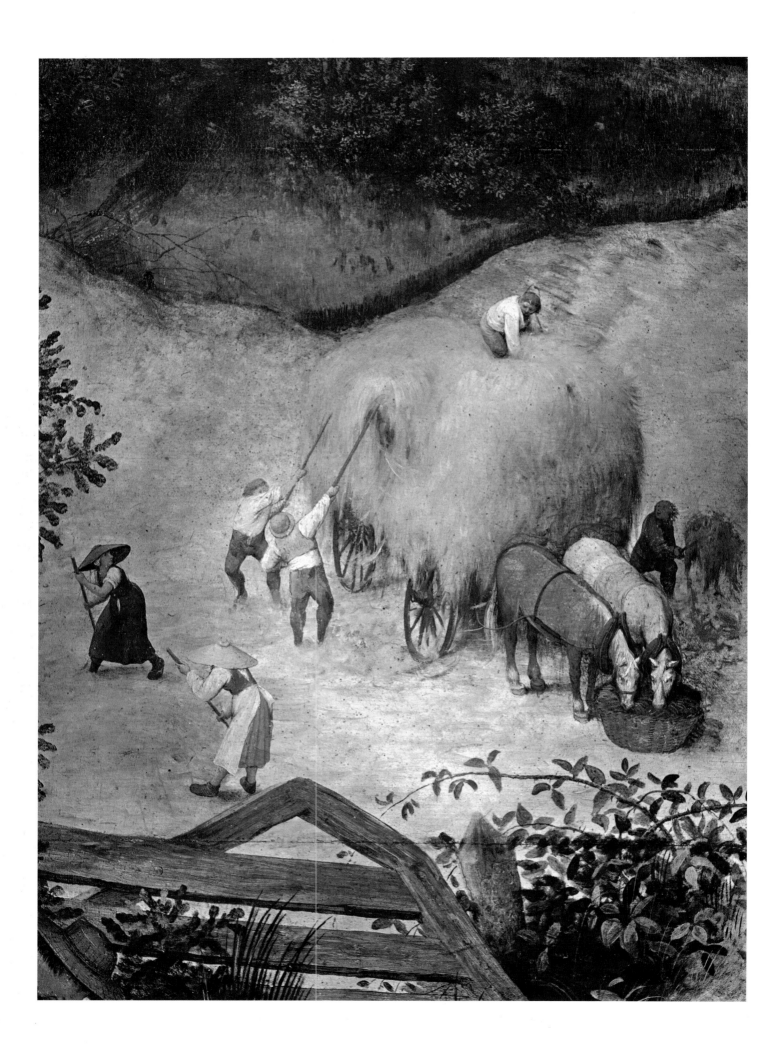

## 31 and 32

## Details from 'Haymaking (July)'

SEE PLATE 30

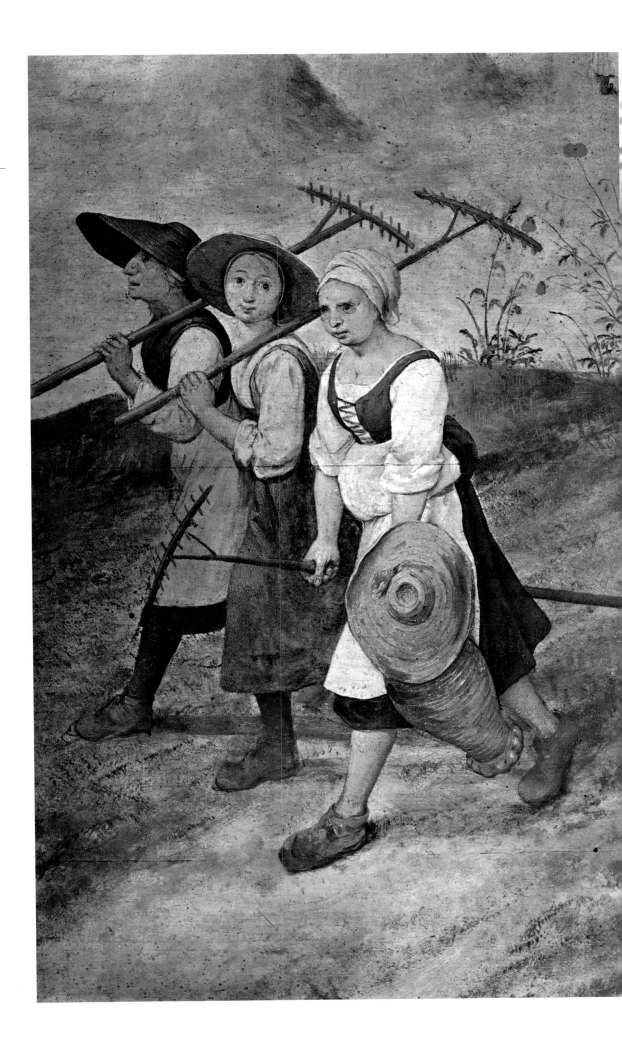

# The Corn Harvest (August)

PANEL, 118 × 160.7 CM (46¼ × 63¼ INS). 1565. NEW YORK, METROPOLITAN MUSEUM OF ART

This is the fourth surviving panel from the series of the *Months* commissioned by the Antwerp merchant Niclaes Jonghelinck (see also Plates 23, 26, 30, and 34). Once again, Bruegel's composition is made up of a harmonious combination of figures and landscape, showing human preoccupations set against a background of nature and religious faith (represented by the chuch on the right). Human activity is made to seem peripheral by the strong evocation of the mood of the landscape.

Fig. 32 (right)
Detail from 'The Corn Harvest' (August)

PANEL, 1565. NEW YORK, METROPOLITAN MUSEUM OF ART

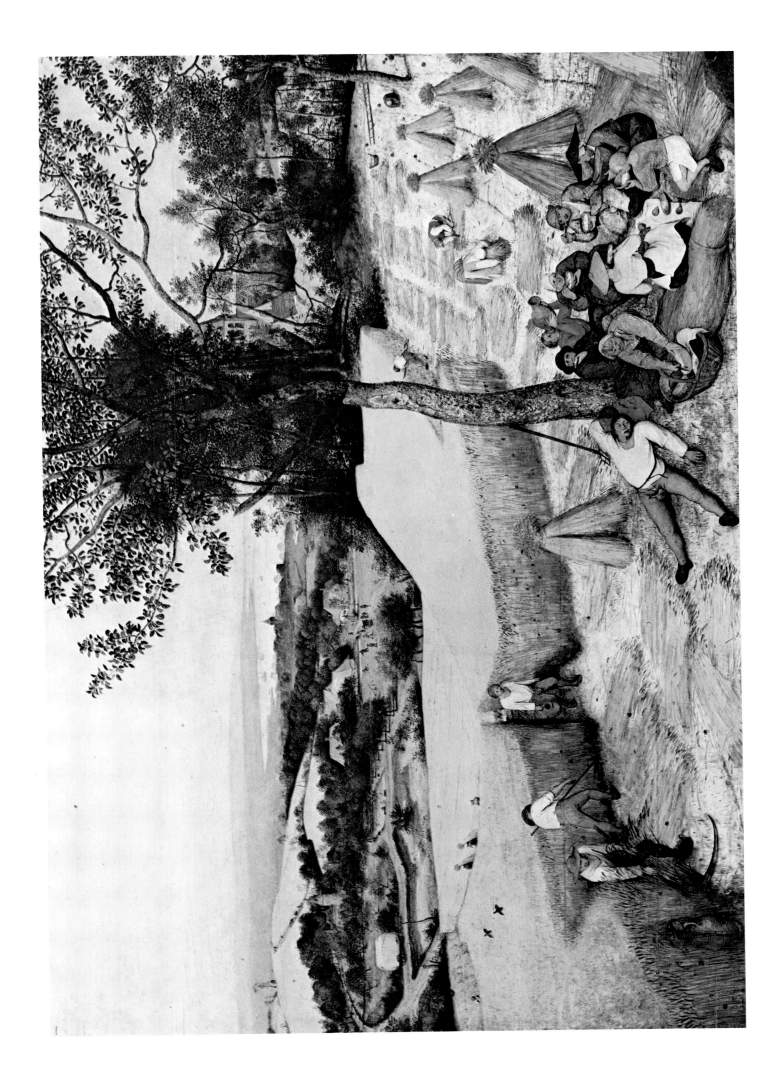

# The Return of the Herd (November)

PANEL, 117 × 159 CM (46 × 62⅝ INS). SIGNED AND DATED, 1565. VIENNA, KUNSTHISTORISCHES MUSEUM

November is the month in which the cattle return to their winter quarters from the summer pastures and Bruegel shows them being driven towards the hill-top village. In this panel Bruegel's remarkable technique can be studied at its best. Individual forms are built up with the greatest economy. Within the sketched outline the paint is laid on thinly, sometimes with an almost dry brush. The light brown gesso underpainting is allowed to show through, in this instance giving a warm brown tone to the whole foreground. Bruegel must have composed the *Months* largely on the panels themselves; only one preparatory drawing on paper survives, a study for one of the hunters in *The Hunters in the Snow* (Plate 23), the January panel. Having prepared the panel, Bruegel drew the outlines of the composition in paint with a thin brush and then added the thinly-scraped areas of colour within those outlines.

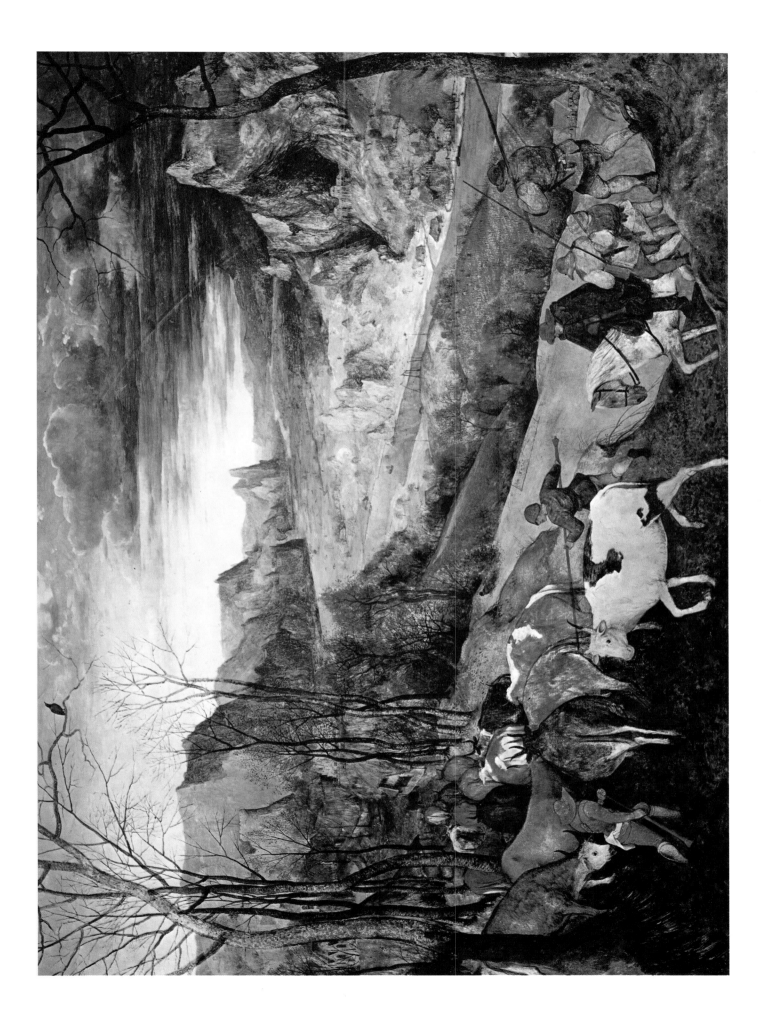

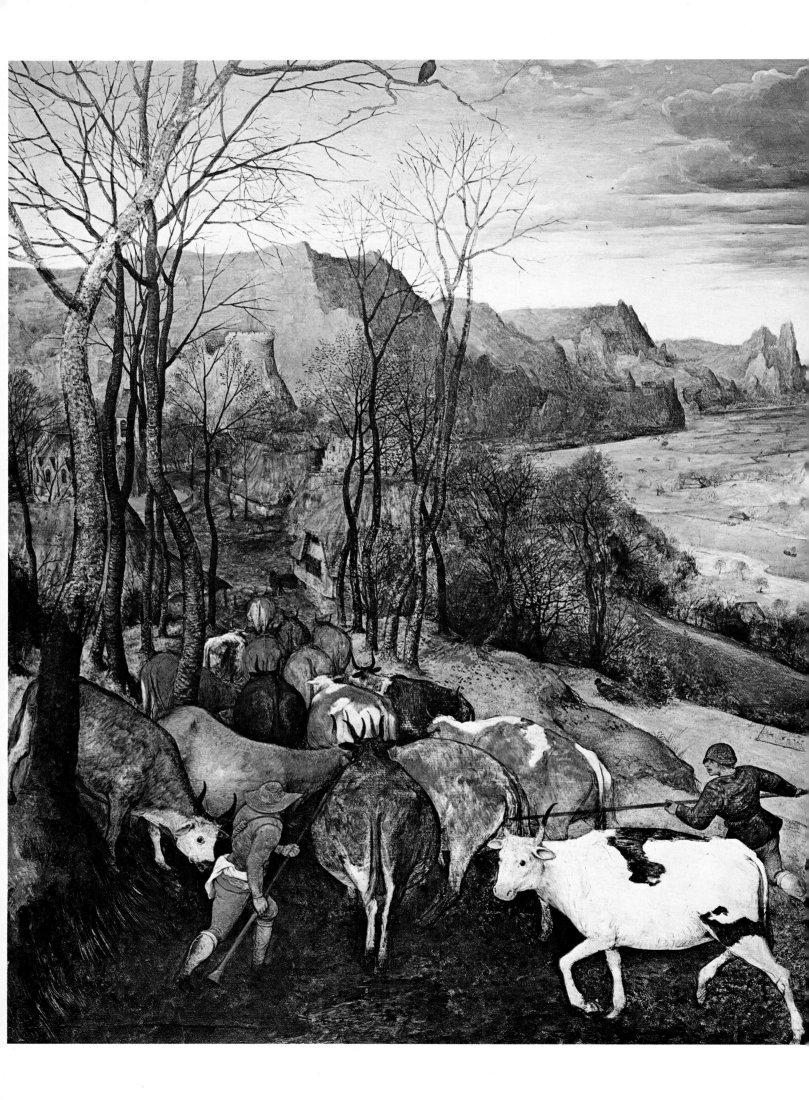

## 35 and 36

Details from
'The Return
of the Herd
(November)'

SEE PLATE 34

# Detail from 'The Numbering at Bethlehem'

SEE FIG. 33

Again Bruegel treats a biblical story as a contemporary event. And once again, reference to particular political events has been adduced — in this case, the severity of the Spanish administration in the southern Netherlands. However, Bruegel may well be making a more general criticism of bureaucratic methods.

The events depicted are described in Luke 2, 1-5: 'And it came to pass in those days, that there went out a decree from Caesar Augustus, that all the world should be taxed ... And all went to be taxed, every one into his own city. And Joseph also went up from Galilee, out of the city of Nazareth into Judaea, unto the city of David, which is called Bethlehem (because he was of the house and lineage of David) to be taxed with Mary his espoused wife, being great with child.'

This is a rare subject in previous Netherlandish art. The ruined castle in the background is based on the towers and gates of Amsterdam.

Fig. 33
The Numbering at Bethlehem

PANEL, 116 × 164.5 CM (45⅝ × 64¾ INS). 1566. BRUSSELS, MUSEES ROYAUX DES BEAUX-ARTS

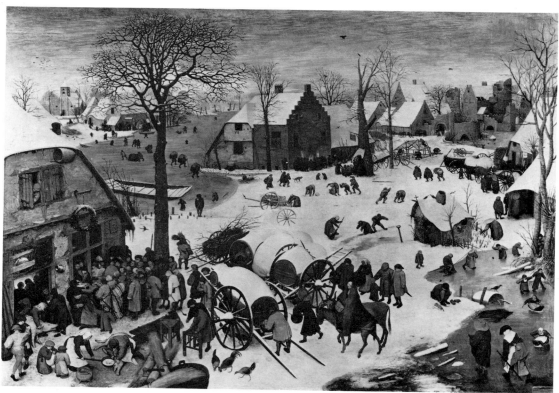

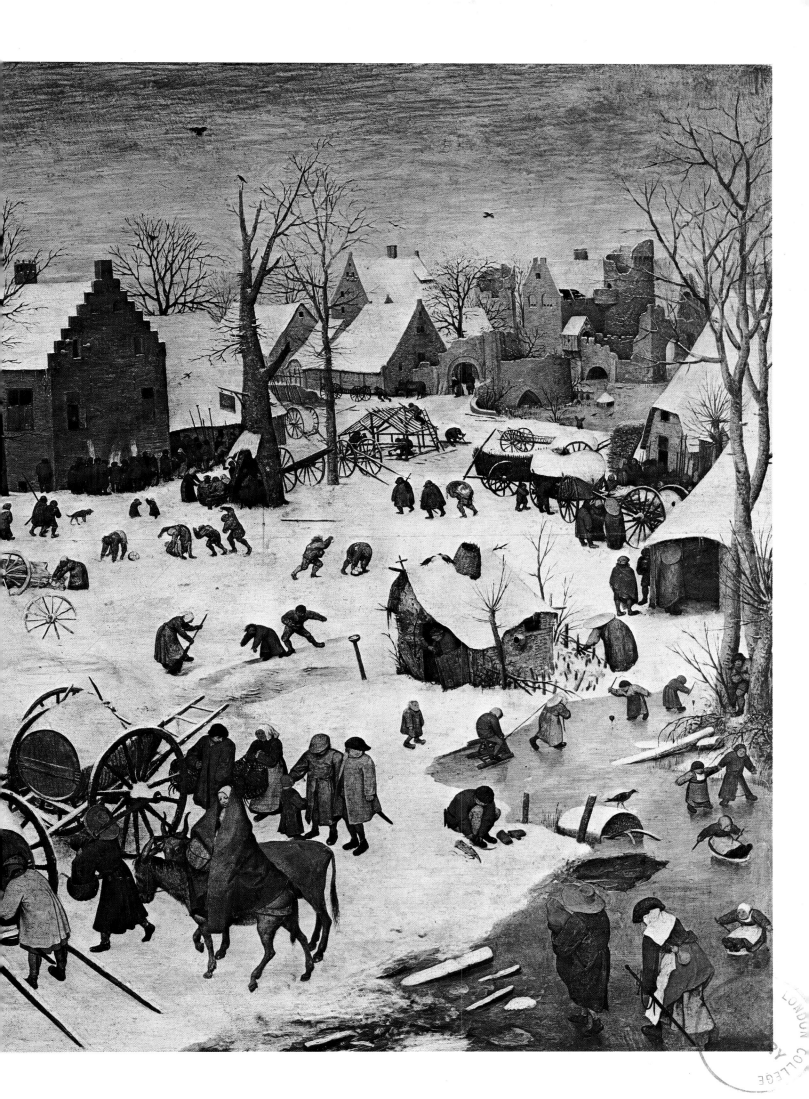

# The Massacre of the Innocents

PANEL, 116 × 160 CM (45⅝ × 63 INS). INSCRIBED. C.1565-7. VIENNA, KUNSTHISTORISCHES MUSEUM

There are two versions of this composition by Bruegel. The original is probably the painting in the Royal Collection at Hampton Court Palace, but that panel is considerably damaged and repainted. The version reproduce here, which is in Vienna, appears to be a workshop replica, perhaps completed by Bruegel himself. Both were painted around 1565-7.

As in the *Procession to Calvary* (Plate 17), Bruegel depicts a biblical event in contemporary terms. In this case he shows the sacking and plundering of a Flemish village. Such scenes were of course only too tragically familiar in Flanders during Bruegel's lifetime, but it is unlikely that the painter intended to condemn a particular act of Spanish aggression. Bruegel was delivering a more general condemnation of war and the individual acts of atrocity which war condones.

Fig. 34
Detail from 'The Massacre of the Innocents'

PANEL, 1566. VIENNA, KUNSTHISTORISCHES MUSEUM

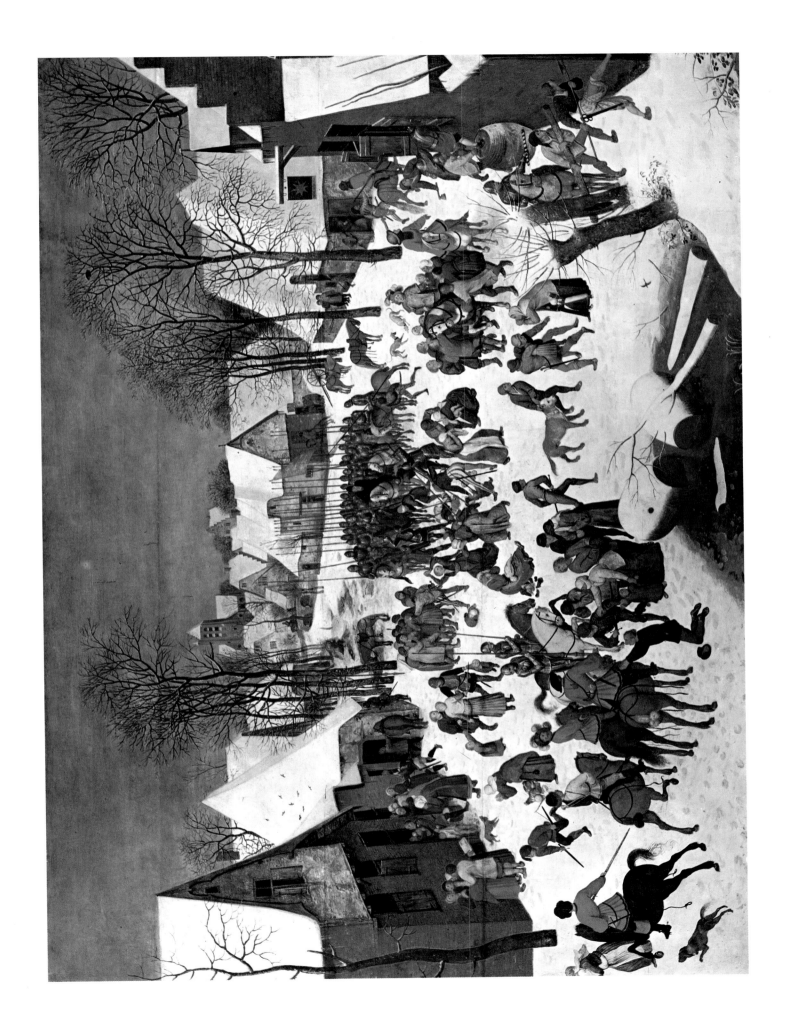

# The Conversion of St Paul

PANEL, 108 × 156 CM (42¼ × 61⅜ INS). SIGNED AND DATED, 1567. VIENNA, KUNSTHISTORISCHES MUSEUM

Bruegel shows Paul's army on its way to Damascus in contemporary dress and with sixteenth-century armour and weapons. The saint himself is in a blue doublet and hose of the painter's day. Bruegel, having lived in Italy, was not unfamiliar with classical dress: his intention in representing biblical scenes in contemporary dress was to stress their relevance to his own time. In view of the persecution and counter-persecution of the Reformation and Counter-Reformation, the story of Paul's conversion had especial significance. The events are described in The Acts of the Apostles 9, 3–7:

'And as he journeyed, he came near Damascus: and suddenly there shined round about him a light from heaven: And he fell to the earth, and heard a voice saying unto him, Saul, Saul, why persecutest thou me? And he said, Who art thou, Lord? And the Lord said, I am Jesus whom thou persecutest … And he trembling and astonished said, Lord, what wilt thou have me do? And the Lord said unto him, Arise and go into the city, and it shall be told thee what thou must do. And the men which journeyed with him stood speechless, hearing a voice, but seeing no man.'

Bruegel is not only illustrating the biblical text; he is also stressing the need for faith and condemning the sin of pride.

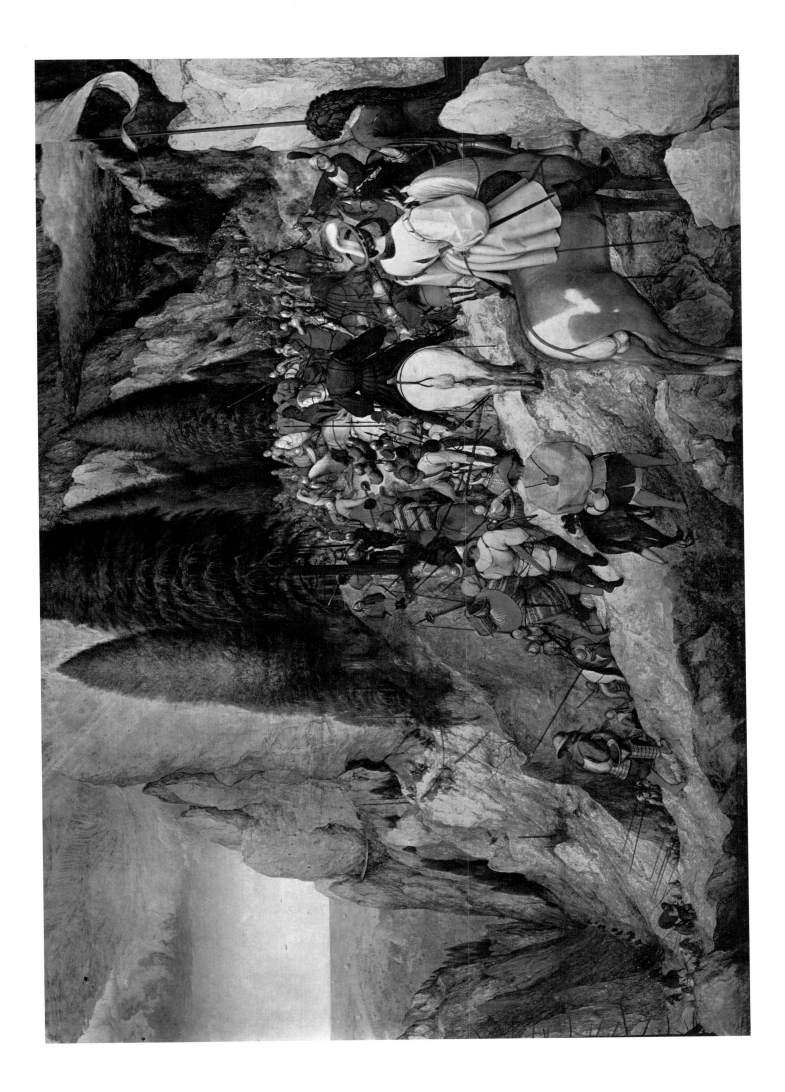

# Detail from 'The Conversion of St Paul'

SEE PLATE 39

Bruegel's depiction of Paul's conversion taking place high up on a pine-clad mountain pass may have been suggested by an engraving of 1509 by Lucas van Leyden. As in the *Procession to Calvary* (Plate 17) and the *Sermon of St John the Baptist* (Fig. 29), Bruegel places the principal figures in the middle distance, almost lost amongst a mass of small figures and behind the eye-catching foreground soldiers and horsemen, who are incidental to the telling of the story. This is a familiar mannerist device which is intended to tease the spectator and draw his eye deep into the picture space in search of the principal subject.

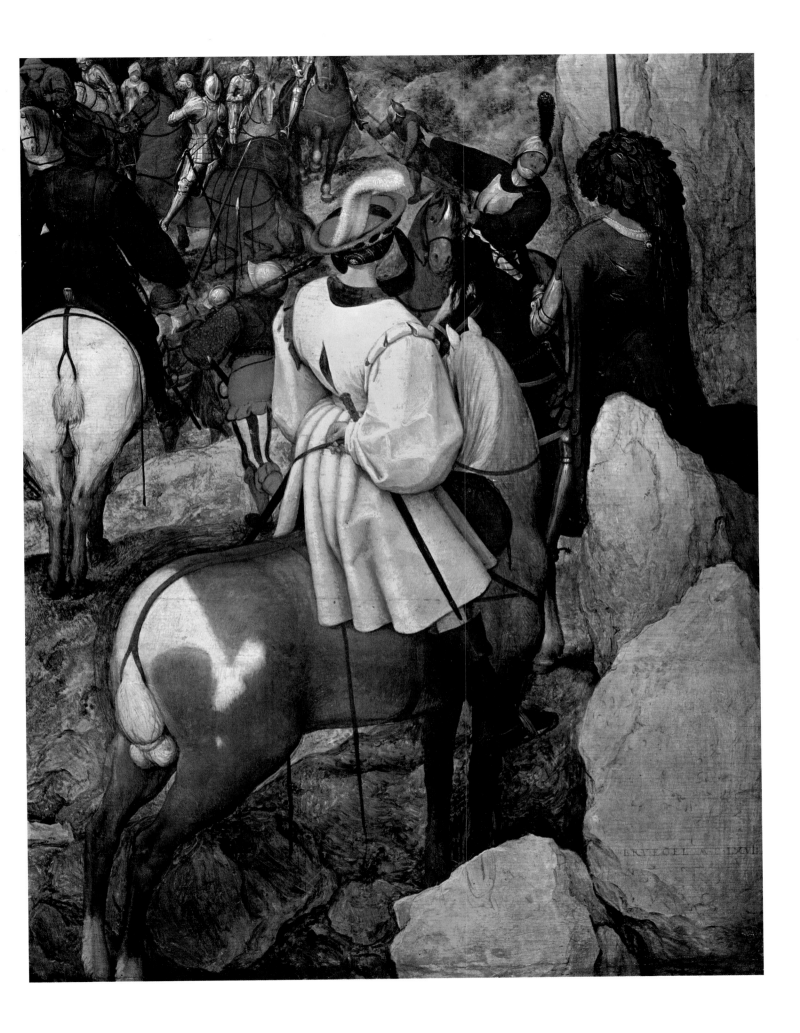

# Detail from 'The Land of Cockaigne'

SEE FIG. 35

Bruegel here represents Never-Never Land, where everything is done for the inhabitant and all there is to do is sleep. His targets are gluttony and sloth; in Dutch the Land of Cockaigne is *Luikkerland* (*lui* meaning lazy and *lekker*, gluttonous). Bruegel has here returned to his earliest Bosch-derived idiom, and in this respect the painting recalls *The Netherlandish Proverbs* (Plate 4).

When an engraving of *The Land of Cockaigne* was published by Hieronymous Cock, a Flemish verse was added to underline the message:

All you loafers and gluttons always lying about
Farmer, soldier and clerk, you live without work.
Here the fences are sausages, the houses are cake,
And the fowl fly roasted, ready to eat.

All three characters are here: the clerk lying on his fur robe, ink and pen at his waist, book beside him; the peasant sleeping on his flail; and the soldier with lance and gauntlet lying useless beside him. Beneath the clerk and the peasant runs an egg, already half-eaten; empty eggshells in Bruegel, as in Bosch, are symbolic of spiritual sterility. Behind the sleepers a roast goose lays itself down on a silver platter to be eaten. To its right a traveller has reached *Luikkerland;* he has eaten his way through a mountain of pudding and is swinging down with the aid of a conveniently placed tree. The fence at the edge of the sleepers' enclosure is woven out of sausages.

Fig. 35
The Land of Cockaigne

PANEL, 52 × 78 CM (20½ × 30¾ INS). 1567. MUNICH, ALTE PINAKOTHEK

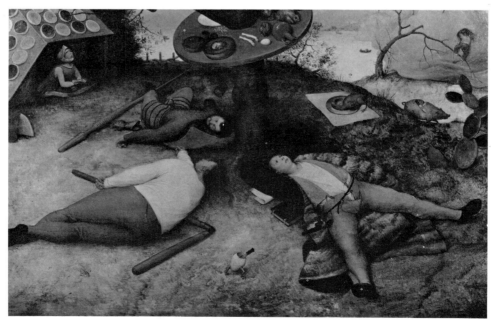

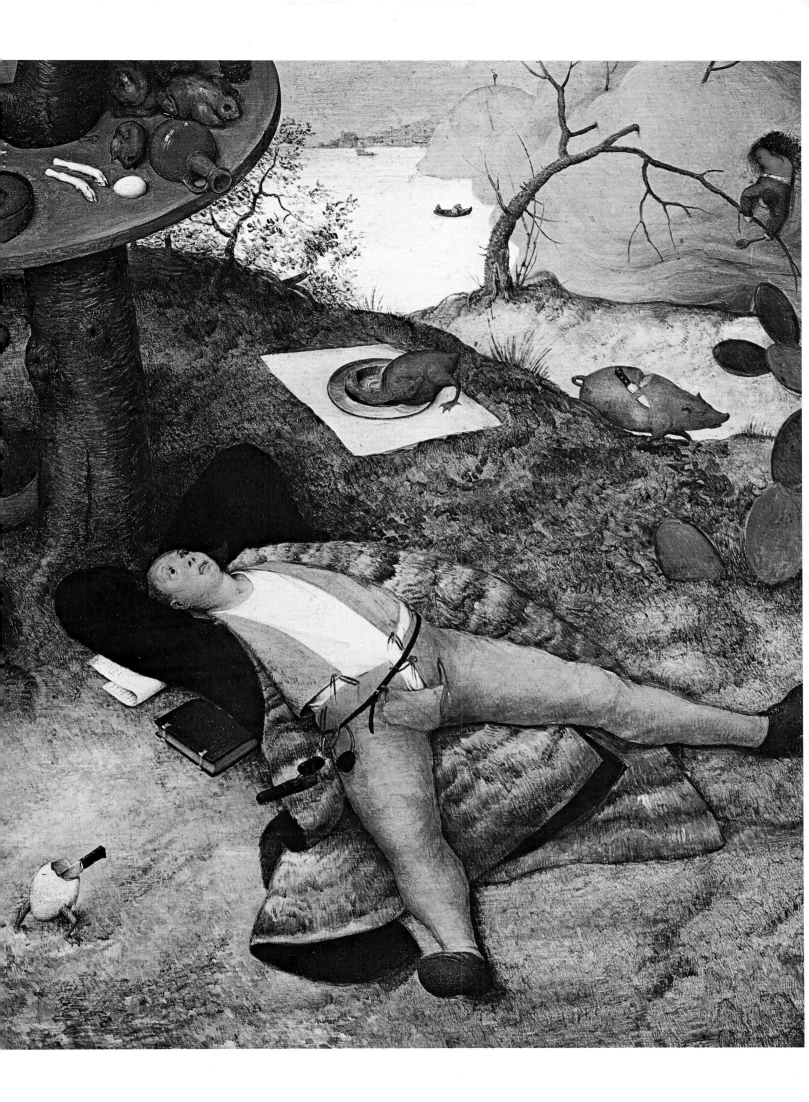

# The Peasant Wedding

PANEL, 114 × 163 CM (44⅞ × 64⅛ INS). C.1567 VIENNA, KUNSTHISTORISCHES MUSEUM

Painted about 1567, this picture has traditionally been thought of simply as a depiction of peasant life. It was paintings of this type which caused Bruegel to be known as Peasant Bruegel. In fact, we now know that he was a leading member of a highly sophisticated humanist circle in Antwerp. With our increasing knowledge of the symbolism contained in much sixteenth-century northern painting, it seems likely that, in addition to the obvious celebration of peasant life, the picture has a moral dimension — the celebration of the sacrament of marriage has simply become an excuse for self-indulgence. Whereas in his earlier engraved work Bruegel represented the Vices as elaborate allegories peopled by Boschian monsters (Fig. 36), here human weakness is commented on in an understated, naturalistic and humorous manner.

The wedding feast is dominated by the figure of the bride who, radiant and composed, presides over the table beneath a canopy. Less obvious is the identity of the bridegroom; he may be the man in black, with his back to the spectator, leaning back on his stool, mug in hand, calling for more wine. A curious detail of the scene which has never been satisfactorily explained is the presence on the far right of a richly-dressed nobleman in earnest conversation with a monk. The monk has presumably just conducted the service of marriage and it has been suggested that he is tediously reminiscing about previous weddings he has attended to the local landowner.

Fig. 36
Gula (Gluttony)

ENGRAVING IN THE 'SEVEN DEADLY SINS' SERIES, 22.5 × 29.5 cm (8⅞ × 11⅝ INS). LONDON, BRITISH MUSEUM

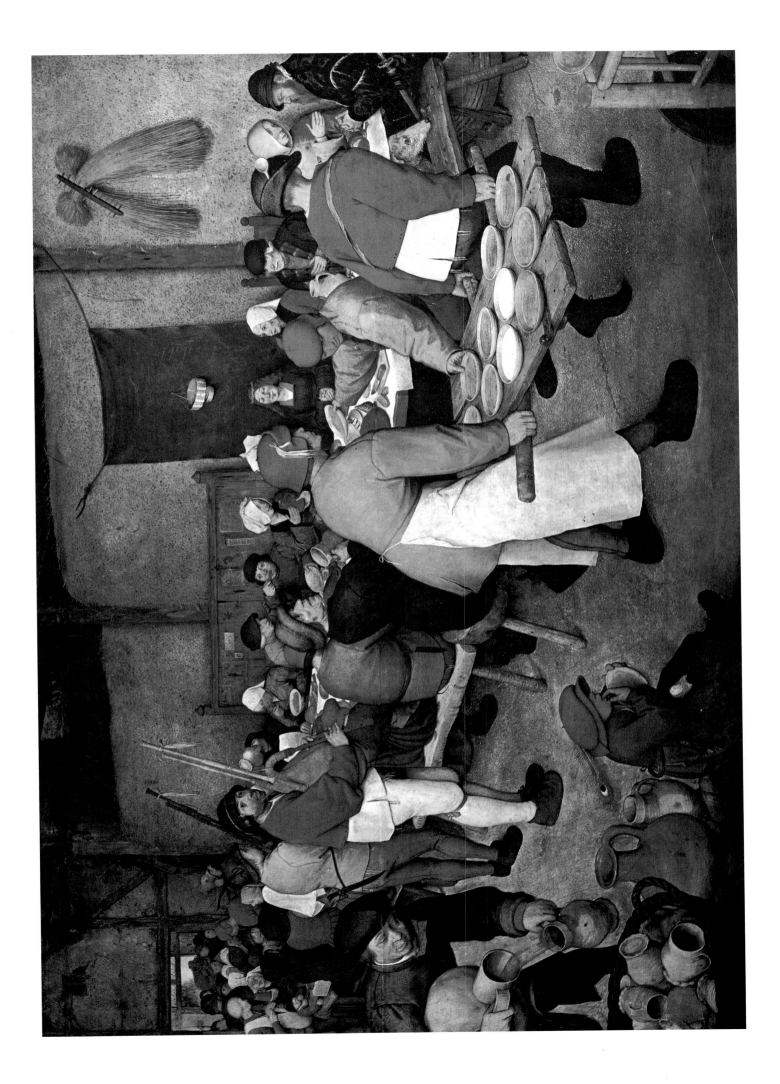

Details from
'The Peasant
Wedding'

SEE PLATE 42

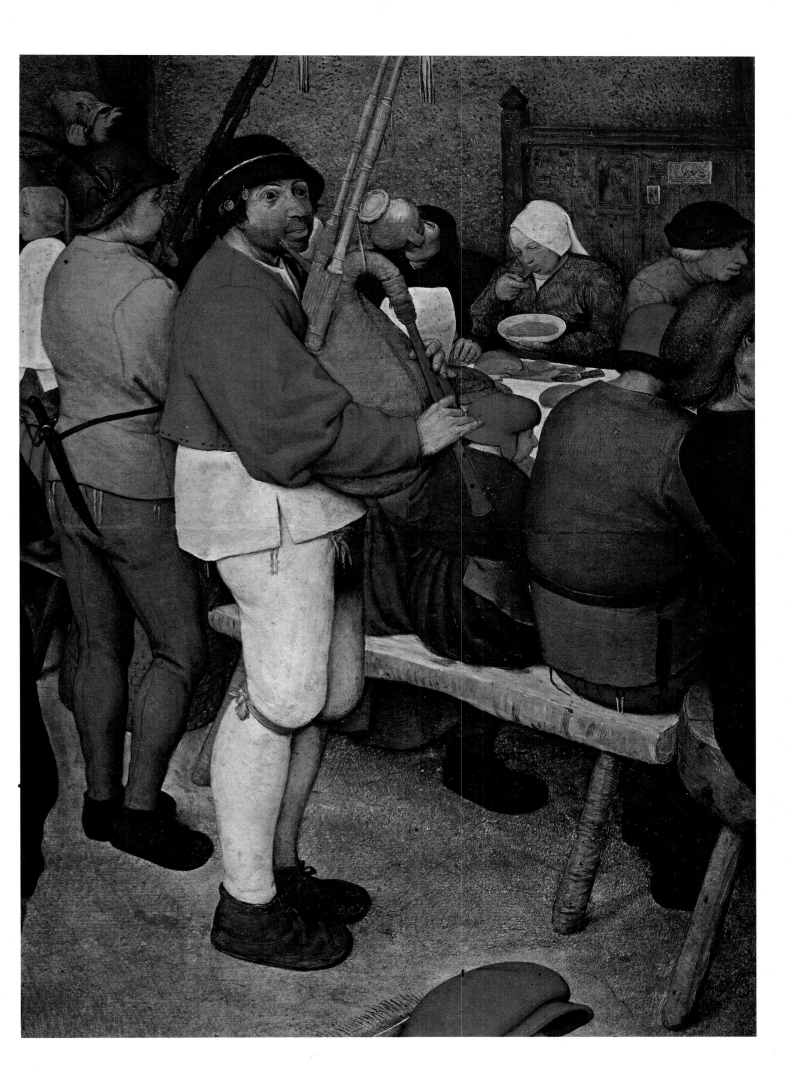

# The Peasant Dance

PANEL, 114 × 164 CM (44⅞ × 64⅝ INS). SIGNED. C.1567. VIENNA, KUNSTHISTORISCHES MUSEUM

This panel, which is not dated, was painted at about the same time as the *Peasant Wedding*, that is, about 1567. The sizes of the two paintings are the same and they may have been intended as a pair or as part of a series illustrating peasant life. They are the two most outstanding examples of Bruegel's late style, which is characterized by his use of monumental Italianate figures.

There is another version of this subject by Bruegel in a painting in the Detroit Institute of Arts (Fig. 37). It is dated 1566 and although the surface is rather worn, it is today generally accepted as an authentic work from Bruegel's own hand. The composition is more crowded and in consequence more effective than the Vienna picture.

Fig. 37
The Wedding Dance in the Open Air

PANEL, 119 × 157 CM (47 × 62 INS). 1566. DETROIT, INSTITUTE OF ARTS

# Detail from 'The Peasant Dance'

SEE PLATE 45

Like the *Peasant Wedding* (Plate 42), it is likely that Bruegel intended this painting to have a moral sense rather than simply being an affectionate portrayal of peasant life. Gluttony, lust and anger can all be identified in the picture. The man seated next to the bagpipe player wears a peacock feather in his hat (Fig. 38), a symbol of vanity and pride. The occasion for the peasants' revelry is a saint's day, but the dancers turn their backs on the church and pay no attention whatsoever to the image of the Virgin which hangs on the tree. The prominence of the tavern makes it clear that they are preoccupied with material rather than spiritual matters.

Fig. 38
Detail from 'The Peasant Dance'

PANEL, C.1567. VIENNA, KUNSTHISTORISCHES MUSEUM

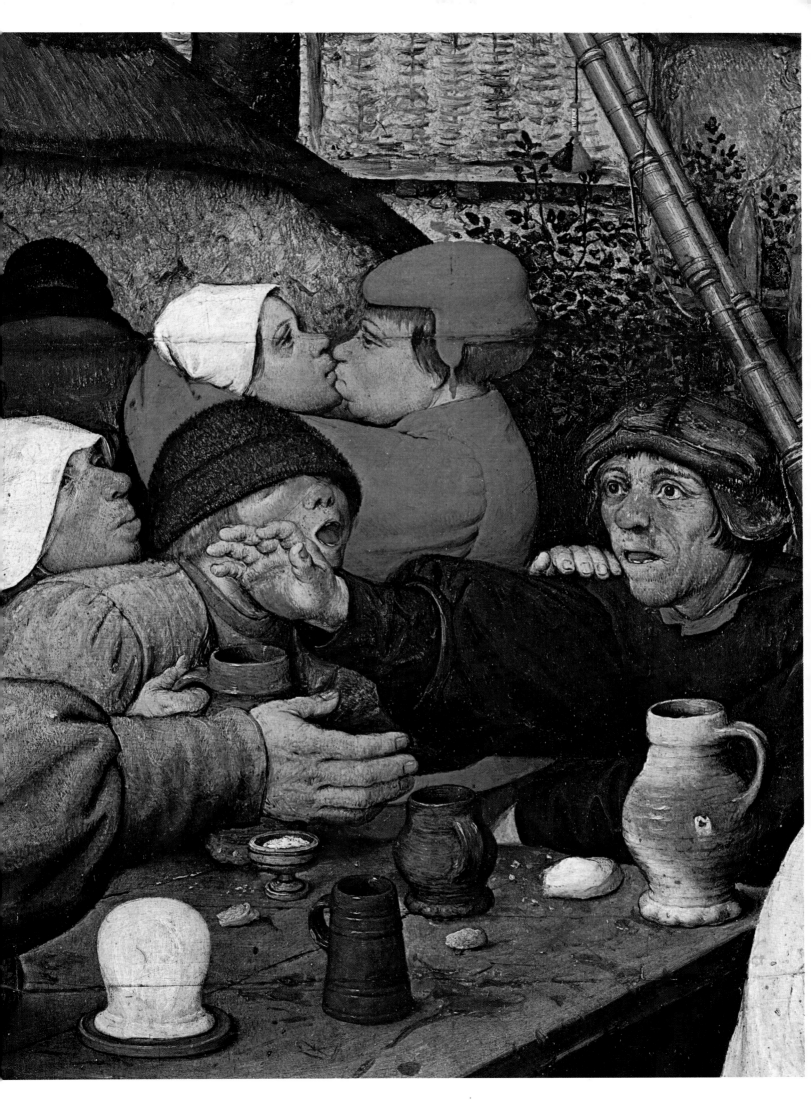

# The Peasant and the Birdnester

PANEL, 59 × 68 CM (23¼ × 26¾ INS). SIGNED AND DATED, 1568. VIENNA, KUNSTHISTORISCHES MUSEUM

Painted in the year before the artist's death, this painting, like other late works such as *The Land of Cockaigne* (Plate 41), *The Peasant Dance* (Plate 45) and *The Peasant Wedding* (Plate 42), is dominated by monumental figures. Immediately after his return from Italy, Bruegel showed no apparent interest in Italian figure-types and compositions, reverting to the Antwerp tradition in which he had been trained. However, in these late works he shows that his study of Italian painting had taken root; these figures demonstrate his knowledge of Italian art and in particular the art of Michelangelo.

This unusual subject apparently illustrates a Netherlandish proverb: 'He who knows where the nest is, has the knowledge; he who robs it, has the nest.' The painting presents a moralizing contrast between the active, wicked individual and the passive man who is virtuous in spite of adversity. It has been suggested that, with his knowledge of Italian art, Bruegel intended the peasant's gesture as a profane parody of the gesture of Leonardo's *St John*.

# The Parable of the Blind

CANVAS, 86 × 154 CM (33⅞ × 60⅝ INS). SIGNED AND DATED, 1568. NAPLES, MUSEO NAZIONALE

In the parable of the blind leading the blind, which is recorded by St Matthew, Christ was illustrating in readily appreciable physical form a spiritual condition — inner blindness to true religion. Bruegel gives visual expression to Christ's words in this truly tragic image. The frieze-like procession of the large-scale figures of six blind men reaches an agonizing climax in the terrified expression of the second, who is falling. In contrast to this staggering line of humanity is the church behind them, strong and solid, representing the faith which gives true vision. Once again, in a late work, Bruegel gives a particular and realistic interpretation to a Christian moral.

The blind were a subject of special fascination to Bruegel. He introduced a group into *The Fight between Carnival and Lent* (Plate 2) and a drawing of 1562 in Berlin also shows a group of three blind people. Other paintings of the blind by Bruegel are mentioned in early inventories. His treatment of them is sympathetic without for a moment being patronizing.

Fig. 39 (right)
Detail from 'The Parable of the Blind'

CANVAS, 1568. NAPLES, MUSEO NAZIONALE

# Detail from 'The Magpie on the Gallows'

PANEL, 45.9 × 50.8 CM (18⅛ × 20 INS). SIGNED AND DATED, 1568. DARMSTADT, HESSISCHES LANDESMUSEUM

This painting is mentioned by Carel van Mander in his life of Bruegel: 'In his will he bequeathed to his wife a painting of a magpie on the gallows. By the magpie he meant the gossips whom he would deliver to the gallows.' As a result, this painting has been thought to represent the idea that harmful gossip — in particular, spiteful accusations of heresy, so common during the religious conflicts of Bruegel's day — brings people to the gallows. However, such an interpretation does not really fit in with our knowledge of Bruegel's attitudes and it is more likely that it refers to a more general notion of the transience of pleasure, and the threat of extinction which hangs over all mortals. The gallows are a *memento mori* which throw a long shadow over the gaiety of the peasants' dance and the beauty of the sunlit landscape.

Most of Bruegel's late paintings are dominated by large figures, but in this one and in the *Storm at Sea* (Plate 51) he is concerned with the rendering of atmosphere, landscape and sunlight.

Fig. 40
The Magpie on the Gallows

PANEL, 45.9 × 50.8 CM (18⅛ × 20 INS). 1568. DARMSTADT, HESSISCHES LANDESMUSEUM

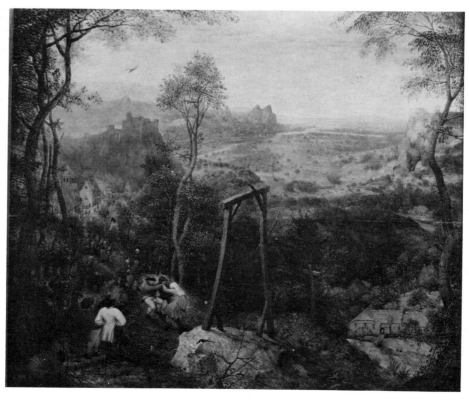

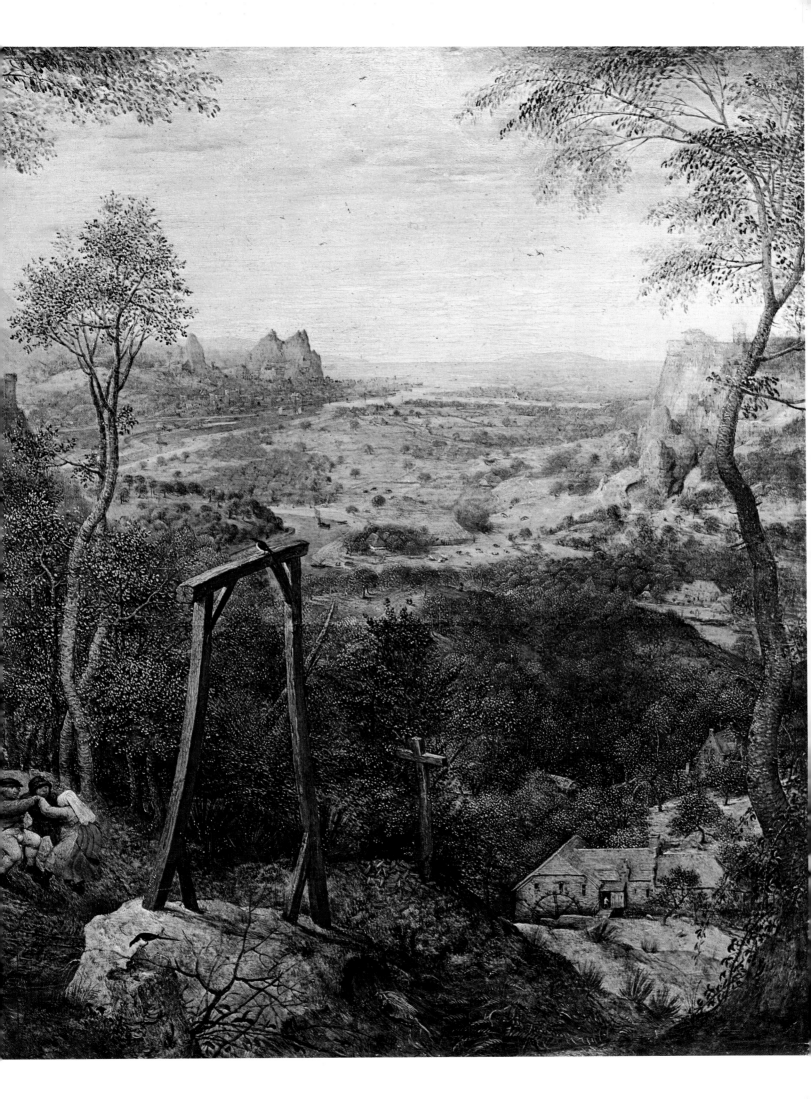

# The Misanthrope

CANVAS, 86 × 85 CM (33⅞ × 33½ INS). SIGNED AND DATED ON THE PAINTED FRAME, 1568. NAPLES, MUSEO NAZIONALE

The Flemish inscription reads: 'Because the world is perfidious, I am going into mourning'. The moral of the painting is that such a relinquishment of the world is not possible: one must face up to the world's difficulties, not abandon responsibility for them. The hooded misanthrope is being robbed by the small figure in a glass ball, a symbol of vanity. His action shows how impossible it is to give up the world. The misanthrope is also walking unawares towards the mantraps set for him by the world. He cannot renounce it as he would wish, and he is contrasted with the shepherd in the background who guards his sheep and who is more virtuous than the misanthrope because of his simple, honourable performance of his duties, his sense of responsibility towards his charges.

Om dat de werelt is soe ongetru
Daer om gha ic in den ru

# Storm at Sea

PANEL, 70.3 × 97 CM (27⅞ × 38¼ INS). C.1569. VIENNA, KUNSTHISTORISCHES MUSEUM

In the past doubts have been raised about the attribution of this painting to Bruegel: the name of Joos de Momper, a landscape painter who became a master in the Antwerp guild in 1581, has been mentioned. However, not only is this painting superior to any by de Momper; its similarity to a drawing by Bruegel (Fig. 41) and its originality of composition and delicacy of execution have made it generally accepted as a late work of Bruegel, possibly left unfinished at his death.

The prominence of the barrel and the whale has led the painting to be associated with the contemporary saying: 'If the whale plays with the barrel that has been thrown to him and gives the ship time to escape, then he represents the man who misses the true good for the sake of futile trifles.' This sense would be underlined by the church outlined against the horizon, which stands for safety amid the storms of life.

Fig. 41
Marine Landscape with a view of Antwerp

PEN AND BROWN INK, 20.3 × 29.8 CM (8 × 11¾INS). LONDON, COURTAULD INSTITUTE GALLERIES

# Select Bibliography

R. van Bastelaer, *Les estampes de Pieter Bruegel l'Ancien,* Brussels, 1908. The standard catalogue of Bruegel's prints.

M. J. Friedländer, *Early Netherlandish Painting. Volume XIV: Pieter Bruegel,* Leyden, 1976. An English translation of Friedländer's 1937 text with notes and a full, up-to-date bibliography by Henri Pauwels.

W. S. Gibson, *Bruegel,* London, 1977. A well-balanced introductory account of the artist.

G. Gluck, *Pieter Brueghel the Elder,* London, 1958.

J. Grauls, *Volkstaal en Volksleven in het werk van Pieter Bruegel,* Antwerp-Amsterdam, 1957. An examination of the relationship of Bruegel's work to popular literature (compilations of proverbs, etc.) and to peasant customs in sixteenth-century Flanders.

F. Grossmann, *Pieter Bruegel: Complete Edition of the Paintings,* third edition, London, 1973. The outstanding modern account of Bruegel the painter.

L. Lebeer, *Catalogue raisonné des estampes de Bruegel l'ancien,* Brussels, 1969. A modern, critical edition of Bruegel's prints.

R. Marijnissen and M. Seidel, *Bruegel,* Stuttgart, 1969.

L. Münz, *Bruegel: The Drawings, Complete Edition,* London, 1961. The standard catalogue of Bruegel's drawings. It includes, however, the so-called *naer het leven* drawings which have subsequently been shown to be the work of Roelandt Savery.

O. van Simson and M. Winner (eds.), *Pieter Bruegel und seine Welt,* Berlin, 1979. The proceedings of a symposium held in Berlin at the time of the exhibition *Pieter Bruegel d. A. als Zeichner,* 1975.

W. Stechow, *Pieter Bruegel,* New York, 1969.

C. G. Stridbeck, *Bruegelstudien,* Stockholm, 1956. Iconographical studies of Bruegel's work.

## EXHIBITION CATALOGUES

*Le siècle de Bruegel,* Musées Royaux des Beaux-Arts, Brussels, 1963.

*Pieter Bruegel d. A, als Zeichner,* Kupferstichkabinett, Staatliche Museen, Stiftung Preussicher Kulturbesitz, Berlin-Dahlem, 1975.

*Bruegel, une dynastie de peintres,* Palais des Beaux-Arts, Brussels, 1980.